Lake Tahoe

Lake Tahoe

A FRAGILE BEAUTY

By Thomas Bachand

Introduction by Dr. Charles R. Goldman

CHRONICLE BOOKS
SAN FRANCISCO

Page 176 constitutes a continuation of the
copyright page.

Library of Congress Cataloging-in-Publication
Data available.

ISBN: 978-0-8118-6309-4

Manufactured in China.

Design by **LEON YU DESIGN**

Typeset in Grotesque MT and Scala

10 9 8 7 6 5 4 3 2 1

Chronicle Books LLC
680 Second Street
San Francisco, California 94107

www.chroniclebooks.com

For my parents, Dorothy and Clifford.

Their enthusiasm for the natural world has been contagious.

Contents

Acknowledgments

This book began many years ago with the suggestion of my good friend, fellow photographer, and camping buddy, John Marriott. Since then, the assistance of many others has propelled this project to completion. For their advice and counsel, many thanks to Edward Bachand, Marguerite Bachand, Philip Bachand, Thérèse Bachand, Malcolm Margolin, Doug McConnell, Ellen Sasaki, and Larry Sultan. Victoria Bradshaw at the Phoebe Hearst Museum of Anthropology and Drew Heath Johnson of the Oakland Museum of California assisted with the historical photography. Robert Hass kindly made his poetry available. Thanks to Victor Naranjo and Hasselblad USA, Russell Brown and Adobe Systems, and Maxtor for facilitating image production and processing.

We all owe a debt to those providing the science that is saving Lake Tahoe. Among them here: Dr. Charles Goldman of the Tahoe Research Group; Dr. John Reuter, Dr. Geoffrey Schladow, and Heather Segale at the Tahoe Environmental Research Center; Dr. Alan Heyvaert of the Desert Research Institute; and, at the USDA Forest Service, Dr. Patricia Manley of the Sierra Nevada Research Center and Dr. Jo Ann Fites of the Adaptive Management Services Enterprise Team.

Many thanks to Alan Rapp, my editor at Chronicle Books, who shepherded this project to publication, and our editorial and design team of Bridget Watson Payne, Jennifer Tolo Pierce, and Leon Yu.

While only a few are mentioned here, I owe a large debt of gratitude to the many people who have supported my photography over the years and lent moral support to my creative endeavors. Kathryn Kowalewski's patience and creative intuitions have marshaled new directions. Grey Crawford has been both a friend and mentor throughout my career. Anne Candia will always remain in my thoughts for her accomplishments as an educator and belief in the realm of possibility and all things creative. Foremost, I would like to thank my parents, Dorothy and Clifford Bachand, and my family. They will forever inhabit my memories of Lake Tahoe and without their continued support this project would have never come to fruition.

9

Not One, but Many

Foreword Thomas Bachand

I struggled against the mountain, looking for a perspective—one that would reveal the conflicted landscape we call Lake Tahoe. With its bare crimson slopes telling of a volcanic past, Red Lake Peak rose majestically above the folded granite of the Sierra Nevada. I reached into the thin air, across spring snowfields, and over damp, coarse, muddy soils alive with a long winter's dissolving snowmelt flowing undecidedly to the desert, Lake Tahoe, or the Pacific Ocean. Above, spires of once-molten rock, now sprayed yellow and orange with lichen, soared skyward.

I was chasing the ghost of John Frémont, who in February 1844 surveyed the Sierra for a young nation. His was the singular perspective that opened the West to a wave of migration that would suddenly and irreversibly change the landscape. On the uppermost slopes of Red Lake Peak, Tahoe comes upon one quickly. In a view that crosses peaks and creases ranges, the inland sea lies quietly and partially obscured, an expanse of smooth blue water more akin to sky than earth.

Frémont was blessed with mild weather and, despite warnings from the local Washoe tribe, embarked on an ultimately successful winter crossing of the Sierra. This is rugged, unforgiving country. The Sierra's record annual snowfall, seventy-three feet, is a mere reminder of the glaciers that buried and shaped these mountains for over a million years. History is conveyed by landmark and headline. In the foothills, ribbons of golden soil mark the infertile legacy of Gold Rush hydraulic mining. Miles of avalanche sheds shield the railroad during winter summit crossings. Annually, errant recreationists, claimed by avalanche or lost to darkness, go missing. A journey that now takes less than two hours once stranded the Donner Party in a winter of desperation. Today, less prepared and aware, we whisk ourselves across these once-impenetrable mountains, impervious to temperature and terrain, and arrive at secure destinations struck by the smell of pine and the damp of the forest.

The arrival of frontiersmen on Lake Tahoe's shores signaled the end of the Washoe's nine-thousand-year semi-nomadic habitation atop the Sierra crest and the western edge of the Great Basin. By 1860, sawmills were established in South Lake Tahoe to supply the Comstock Lode's tremendous demand for lumber. Thirty years later, only the Tahoe Basin's inaccessible slopes remained forested. Grazing sheep further damaged the exposed soil. Watershed degradation, the introduction of non-native species, and overfishing drove native fish stocks to extinction. From this environmental catastrophe sprang Tahoe's "Golden Age." Along with resorts and private estates, an appreciation of the area's beauty and the seeds of a conservation effort evolved. Tahoe existed quietly until the post–World War II era of freeways and development opened it to the middle class. Construction in the basin began in earnest, and the politics of development versus preservation dictated Tahoe's course. Eventually, nearly 90 percent of the Tahoe Basin came into the public domain. In 1873, geologist John LeConte measured the lake's water clarity to a depth of 108 feet. In the ensuing 130 years that figure has fallen to 64 feet. Public concern for Tahoe's health has made it one of the most studied and regulated ecosystems in the nation.

To turn back from Frémont's vantage point, though, is to discover a different perspective from Red Lake Peak—a Washoe perspective that may be everlasting. Any thoughtful

look at Tahoe necessarily carries one well beyond its borders. On an average day, from the foot of the peak's once-molten spires, one sees much of Washoe country. On a good day, the horizon from the crest of the Sierra Nevada seems to bend as the views from Red Lake and neighboring peaks touch the Coast Range, the Sacramento Valley, and Nevada's Great Basin. Hazy days witness California's metropolitan ozone rising east over the mountains and settling on the Sierra's snowmelt and alpine lakes. Creeping more slowly into the Sierra is a demand for second homes, commuter communities, and resorts that mine the land for the American dream of country living, luxury, leisure, and recreation. No longer is this a vast, unexplored wilderness holding unknown treasures. Urban sprawl, regional air pollution, a growing appetite for recreational opportunities, the specter of global warming—in many respects, Tahoe is a case study in America's challenge to manage consumption pressures while sustaining the environment.

Tahoe, though, is more than an environmental report card. It is emblematic of our relationship with the landscape. When we reduce Tahoe to numbers and calculations, we deny a social and national significance, which touches other horizons. For the Washoe, Da-ow's waters gave birth to all others. Man was governed by nature. Lives were shaped by a larger world, one of its own making.

In 1873, John Muir wrote in a letter, *Tahoe is surely not one but many. As I curve around its heads and bays and look far out on its level sky fairly tinted and fading in pensive air, I am reminded of all the mountain lakes I ever knew, as if this were a kind of water heaven to which they all had come.*

Muir is a bridge from our modern culture to the more elemental world of our ancestors and a reminder of the primal connection we share with the earth.

The photography in this book depicts both the one—a spiritual landscape where light plays off water, sky, and earth—and the many—the waters of history, economy, and ambition that indelibly shape this landscape. Single, sublime, and often fleeting moments communicate a permanent truth found only in nature. By embracing the historical perspective—our connection with both past and future—this work attempts to achieve a sense of honesty, or naiveté, found when one first encounters the landscape. With those images depicting society's transitional attitudes toward the environment and the land, the intent is not to mourn the loss of nature but, instead, to convey the disharmony intrinsic in human affairs. While nature is the final arbiter, our mere presence alters the land.

Notable examples of this are Plates 45–50 showing smoke from the 7,700-acre Fred's Fire of 2004, which was located beyond the edge of the basin near Kyburz, not far, as the crow flies, from Red Lake Peak and Frémont's vantage. Only a few structures burned. At the lake, the smoke obscured the basin's rim for days. Piers, boats, and other alterations to the landscape stood apart from the natural setting, accentuated against the grey-brown background, itself a product of man's activities. Three years later, the smaller Angora Fire had a much more devastating effect on the Tahoe community. While less than half the size of Fred's Fire, nearly 250 homes were destroyed and erosion risks were exacerbated along the south shore.

For me, the sight of burning neighborhoods brought back memories of the Oakland firestorm of 1991 and those deep feelings of loss that come from the destruction of one's family home and community. I recalled the two worlds in which I, with little more than the clothes on my back, found myself. The unfathomable forces driving such events make

clear the enormity of the natural world and its indifference to our fragile place within it. Conversely, as if to underscore a fundamental incompatibility with nature, I had been ejected from our material culture.

The similarities between the Tahoe and Oakland fire events are striking. Significant to the destructive power of the Oakland fire were the tightly-spaced homes and non-native trees and plants crowding densely-wooded streets. Like Tahoe, the denuding of Oakland's forests was a product of gold fever. Prior to becoming construction material for San Francisco, Oakland's giant old-growth redwoods were trusted landmarks to schooners entering the Golden Gate and navigating San Francisco Bay. Tahoe's lumber was destined for the silver mines of Virginia City.

Today, Tahoe's forests differ substantially from their pre-settlement state. They have grown more homogeneous, dense, disease-prone, developed, and highly combustible. Illustrating the complex web in which we find ourselves entangled is the breadth and depth of research on every aspect of Tahoe's environment, including biodiversity, soils, air quality, water quality, socioeconomics, and global warming. While Tahoe's sublime vistas always capture me, it is upon closer contemplation that I inevitably find myself at those intersecting landscapes, brought on by our industriousness, dreams, and ambitions.

At the heart of these intersections is Dr. Charles R. Goldman, University of California at Davis Professor of Limnology and Director of the Tahoe Research Group, who in his introduction to this book brings us inside the discovery of this landscape's complexity at perhaps the most pivotal time in recorded history. Supporting charts and graphics from the UC Davis Tahoe Environmental Resource Center, Desert Research Institute, and the United States Forest Service distill volumes of modern research for a glimpse of the forces driving Tahoe's future. From the landscape's historic junction, in the midst of the migration that followed Frémont, come two timeless visions. Master nineteenth-century photographer Carleton Watkins' work throughout the West offers witness to the end of wilderness and indigenous cultures and the establishment of today's communities and ethics. Mark Twain writes across centuries, as if speaking directly to our time, and describes the American pioneering character, one torn between awe and exploitation. Finally, Robert Hass captures Tahoe as a leisure destination and backdrop to our contempory, personal, and distracted lives.

I sat on Red Lake Peak for hours, taking in the landscape and Tahoe's place within it. I thought of Frémont and his cartographer standing beside me on that promontory, reveling in a premature spring, celebrating achievement, and recording discoveries. By now, the land has all been parceled, sectioned, claimed, and its features optimistically labeled—Hope, Charity, Emerald, Heavenly. Invisible boundaries demarcate ambitions, fears, and dreams. Neither the rivers nor the forest are the wiser. Ultimately, the land is not measured by distance or dollar. To view our world only through an economic eyeglass such as Frémont's is to obstruct the naked eye. I thought of the Washoe below, moving respectfully through this landscape, celebrating family and the gifts of nature. If there was a singular perspective from Red Lake Peak, perhaps it was not of those seeking a guidepost or benchmark toward growth and prosperity, but rather, it was one grounded in a more fundamental recognition of our place in the landscape, inspired by an inner peace and wonder that sustains the soul.

Five Decades of Environmental and Social Change at Lake Tahoe

Introduction Dr. Charles R. Goldman

The scene that greeted General John Frémont in 1844, when he saw Tahoe for the first time as one of the early American visitors to the far West, is very different from today's view of the lake and its surrounding watershed. Old-growth trees of enormous size dominated the forest, giving the land a parklike appearance, where horseback riders could easily pass among the trees. A few years later, when the Comstock Lode of silver and gold was discovered below what is now Virginia City, Nevada, most of these giants were felled to shore up the mineshafts as miners dug deeper and deeper in search of new wealth.

My first view of the cobalt-blue waters of Tahoe, in September 1958, reminded me of clear, pristine Becharof Lake on the Alaska Peninsula, where I had completed my doctoral dissertation. Some early limnologists, including the famous Yale University Sterling Professor G. Evelyn Hutchinson, had briefly visited Tahoe before that time, but very little was actually known about this remarkable deep lake formed by extensive faulting at the crest of the Sierra Nevada. What was known was largely the work of fisheries biologists from the California and Nevada Departments of Fish and Game. Among them were Ted Franz from Nevada and Almo Cordone from California.

At a young age I had developed an interest in aquatic ecology by accompanying my father, an English professor, on fishing trips in central Illinois. Although he was a Chaucer and Spenser scholar, his real love was ichthyology, and for over forty years, he carefully recorded the high diversity of his catch as well as stream conditions. In 1959, as a young instructor just hired by the zoology department at the University of California at Davis, I began research projects at both Lake Tahoe and Castle Lake. Over the years, smaller Castle Lake, located just west of Mount Shasta and undeveloped, has served as a comparison lake for Lake Tahoe. I began applying analytical techniques for measuring algal growth rates that I had developed as a graduate student in Alaska. The similarity of Tahoe's algal growth rates to those of the Alaskan lakes was evidence of its still-pristine condition. These initial measurements marked the beginning of long-term Tahoe monitoring, which continues to this day.

During this time in the late 1950s, Pope Marsh, the largest wetland in the entire Sierra Nevada, was being sculpted into a giant housing and marina development called the Tahoe Keys. This wetland's destruction would become the single largest disruption to the Tahoe watershed since the clear-cutting of the forest during the Comstock Lode days. The basin's largest tributary, the Upper Truckee River, had previously meandered through the Pope Marsh wetland on its way to the lake. As the river spread out near its mouth and slowed, the wetland captured and retained sediments and provided biogeochemical conditions for removing and sequestering nutrients from the water. However, the development diverted the river to the east side of the Tahoe Keys and into an artificial canal system, eliminating the wetland's beneficial conditions.

During my university studies I had become interested in eutrophication, the process by which surface waters are enriched with nutrients from domestic, industrial, and agricultural pollution, and the resultant greening of lakes through algal growth. The main nutrient contributors to this process were typically nitrogen, phosphorus, and, to a lesser extent, trace elements and iron. In the 1960s, algal growth in the pristine Tahoe waters was limited by a lack of

nitrogen. This controlled the lake's fertility and, hence, was responsible for its remarkable clarity.

We continued the practice begun by John LeConte, a professor at the University of California at Berkeley, who, in 1873, was the first to study Lake Tahoe and measure its clarity. Yet, instead of using a white dinner plate as LeConte had, we used a Secchi disk, an eight-inch-diameter disk whose use was pioneered by Father Pietro Secchi aboard a papal naval vessel in 1865. Lowered into Tahoe, we made observations to over one hundred feet of depth in 1968. During the ensuing decades, air pollution and erosion increased Tahoe's nitrogen levels to the point where its water conditions shifted toward those of greener midwestern and eastern lakes. In those lakes, an abundance of nitrogen creates conditions where phosphorus, not nitrogen, is the nutrient most limiting to algal growth. By 1980, Tahoe's clarity had decreased by about thirty feet as a result of accumulating nitrogen and phosphorus, with its enhanced algal growth, and stream-deposited fine sediment particles from disturbed watersheds and atmospheric dust.

Responses to the reduction in clarity began with small steps. Eight years of preliminary research and a desire to consolidate and focus lake research led me to found the Tahoe Research Group (TRG) in 1967 at the University of California at Davis. Our research beginnings were humble, with our field and laboratory work conducted out of garages and borrowed space and aboard a 1942 Monterey Salmon trawler captained by Robert Richards. Eventually, we settled in the old 1921 Fish Hatchery on the north shore of Tahoe just east of Tahoe City, outfitting the noninsulated facility with furniture and cabinets salvaged from condemned buildings on the expanding Davis campus. Grant money from the National Science Foundation provided for the purchase of a research vessel, which we named *John LeConte*. After more than thirty years, this vessel still provides a year-round platform for data collection by our scientists, as well as those from many other institutions.

The first steps in addressing the pollution threats to Tahoe were taken by a short-lived but effective organization known as the Tahoe Area Council, which, in the early 1960s, with a Fleishman Foundation grant, studied the sewage problem in the basin. I consulted as a limnologist on the project with an eminent team of sanitary engineers from the University of California at Berkeley, Stanford University, the University of Wisconsin, and the Swiss Federal Water Agency. The initial plan called for treated sewage and wastewater to be deposited after treatment into Lake Tahoe. The results of my bioassay experiments convinced the engineers that the effluent had to be exported from the basin. Had this not been accomplished, Tahoe's water quality would have been much more seriously degraded in the years that followed.

Just prior to my arrival at Tahoe, shoreline residents and summer homeowners concerned with increasing development established the League to Save Lake Tahoe in 1957. Today their "Keep Tahoe Blue" bumper stickers can be seen all across the country. The league took an immediate interest in the scientific research and year-round water quality monitoring established by the TRG. Six years of data collection had established that algae growth was a leading contributor to Tahoe's loss of clarity. Armed with this research and pictures of large sediment plumes entering the lake from various tributaries, the league and I approached both Governor Paul Laxalt of Nevada and newly elected Governor Ronald Reagan of California to enlist their support in saving Lake Tahoe.

From this was born, in 1969, a historic and unprecedented bi-state agency, the Tahoe Regional Planning Agency (TRPA). Under federal mandate, the TRPA was charged with bringing development under control and slowing the deterioration of the lake. The agency's establishment in the face of substantial opposition was a courageous act codifying the public sentiment that Lake Tahoe must be protected. Put to rest were such schemes as building a freeway along the west shore, complete with a bridge across Emerald Bay. Over the years, as its board was expanded to include out-of-basin representation, the TRPA gained in stature. Soon the League to Save Lake Tahoe, through an order by Federal Judge Edward J. Garcia, was able to secure a two-year moratorium on new construction in the basin. We further assisted the TRPA in litigation, at times with cases taken to the Nevada Supreme Court. Through it all, the TRPA gradually found its footing, developed steadfast oversight, and established its authority.

In the early 1980s, the league and the California Attorney General's office joined with the TRPA to press the State of California to establish and fund the Tahoe Conservancy so as to develop conservation measures on the California side of the lake. The findings of the TRG soon became officially accepted: algae attached to the near shore bottom, called periphyton, was turning Tahoe's rocky depths green and slippery. At the same time the lake was losing an average of a foot of clarity annually, while the rate of algal growth was increasing by about 5 percent per year. In the five decades since I began my research, Tahoe has lost a third of its clarity. As knowledge of Tahoe's plight increased among local residents, acceptance grew that unless the lake was protected, everyone eventually would suffer as tourism and real estate values declined in concert with environmental degradation.

The growing concern for Tahoe has attracted many talented scientists from around the world to the TRG. Buoyed by five decades of research by faculty, students, and doctoral associates, the level and quality of science on Tahoe have been substantial. Internationally, Tahoe is now a leading case of an environmental problem being addressed at an early stage. The world's eyes were upon us in 1997 when both President Bill Clinton and Vice President Al Gore, accompanied by a contingent of major media, visited Lake Tahoe and spent time on board the research vessel *John LeConte* observing water monitoring and discussing the future of Tahoe. President Clinton recommended hundreds of millions of dollars in federal support be committed over a twenty-year period for Tahoe conservation and restoration. Annual Tahoe Summit meetings are now arranged by Nevada's and California's U.S. senators.

Late in 2006, UC Davis, in partnership with Sierra Nevada College, opened new facilities for the study of Lake Tahoe in Incline Village. UC Davis, the University of Nevada at Reno, and the Desert Research Institute now work closely together in the Tahoe for Environmental Research Center. This new facility shows great promise for meeting a host of research objectives and environmental challenges to Tahoe's future.

Among the most pressing issues for Lake Tahoe are stormwater runoff from the urbanized portions of the landscape, automobile and boat pollution, atmospheric and road dust, erosion from the surrounding disturbed watershed, and fire danger from the dead and dying white fir forests that grew in dense stands following the Comstock clear-cutting. While best management practices are being enforced throughout the basin to address water pollutants,

substantial work is still needed. Threats from automobile traffic and air pollution have so far defied solution.

Even more daunting are the effects of global climate change, which are altering the thermal characteristics of most lakes worldwide, particularly in the northern hemisphere. These broader changes have serious implications for Tahoe's future. The World Water and Climate Network was established in 2003 following the Third World Water Forum in Kyoto, Japan, to assemble the best possible information on inland water problems associated with climate change. Long-term data from the TRG has been an early contribution to this effort. The most recent thirty-two years of temperature data collection at Tahoe show a gradual long-term warming trend of one degree. These findings are consistent with studies in other parts of the world. Further warming will decrease Lake Tahoe's deep mixing, which now occurs only about every fourth year. By oxygenating the deepest waters, this mixing provides habitat for deep-dwelling fish and invertebrates.

Lake Tahoe is an unparalleled natural resource and a microcosm of the challenges facing all freshwater ecosystems. In many respects, it is emblematic of our relationship with nature. Despite the stresses brought upon Lake Tahoe by the Comstock Lode in the nineteenth century and, more recently, the post–World War II development boom, Tahoe has shown an ability, when given the opportunity, to recover the purity inherited from the last ice age. It is my hope that, just as the Washoe and Twain's generation bequeathed this "Jewel of the Sierra" to us, we will leave a legacy to future generations befitting this prize of nature.

Lake Tahoe

Maps

Newcastle
· PLATE 79

· PLATE 70

Truckee
· PLATE 34 · PLATE 52
Donner Summit

Meyers

· PLATE 33
Echo Summit

· PLATE 30
· PLATE 23
West Carson Canyon

· PLATE 76
Pollock Pines

· WATKINS A
Round Top

· PLATE 32
Red Lake Peak

· PLATE 31
Silver Lake

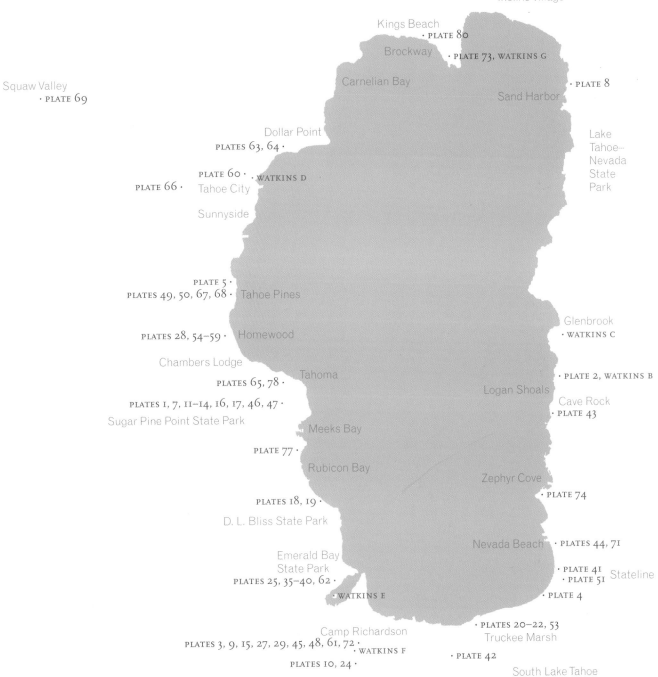

· PLATE 6

Incline Village

Kings Beach
· PLATE 80

Brockway
· PLATE 73, WATKINS G

Carnelian Bay

Squaw Valley
· PLATE 69

Sand Harbor

· PLATE 8

Lake
Tahoe–
Nevada
State
Park

Dollar Point
PLATES 63, 64 ·

PLATE 60 ·
· WATKINS D

PLATE 66 ·
Tahoe City

Sunnyside

PLATE 5 ·
PLATES 49, 50, 67, 68 ·
Tahoe Pines

Glenbrook
· WATKINS C

PLATES 28, 54–59 ·
Homewood

Chambers Lodge

Tahoma

· PLATE 2, WATKINS B

PLATES 65, 78 ·

Logan Shoals

Cave Rock
· PLATE 43

PLATES 1, 7, 11–14, 16, 17, 46, 47 ·

Sugar Pine Point State Park

· PLATE 75
Carson City

Meeks Bay

PLATE 77 ·

Rubicon Bay

Zephyr Cove

· PLATE 74

PLATES 18, 19 ·

D. L. Bliss State Park

Nevada Beach
· PLATES 44, 71

Emerald Bay
State Park

· PLATE 41
· PLATE 51
Stateline

PLATES 25, 35–40, 62 ·

· WATKINS E
· PLATE 4

Camp Richardson

· PLATES 20–22, 53
Truckee Marsh

PLATES 3, 9, 15, 27, 29, 45, 48, 61, 72 ·
· WATKINS F

· PLATE 42

PLATES 10, 24 ·

South Lake Tahoe

· PLATE 26

Plates 1–26

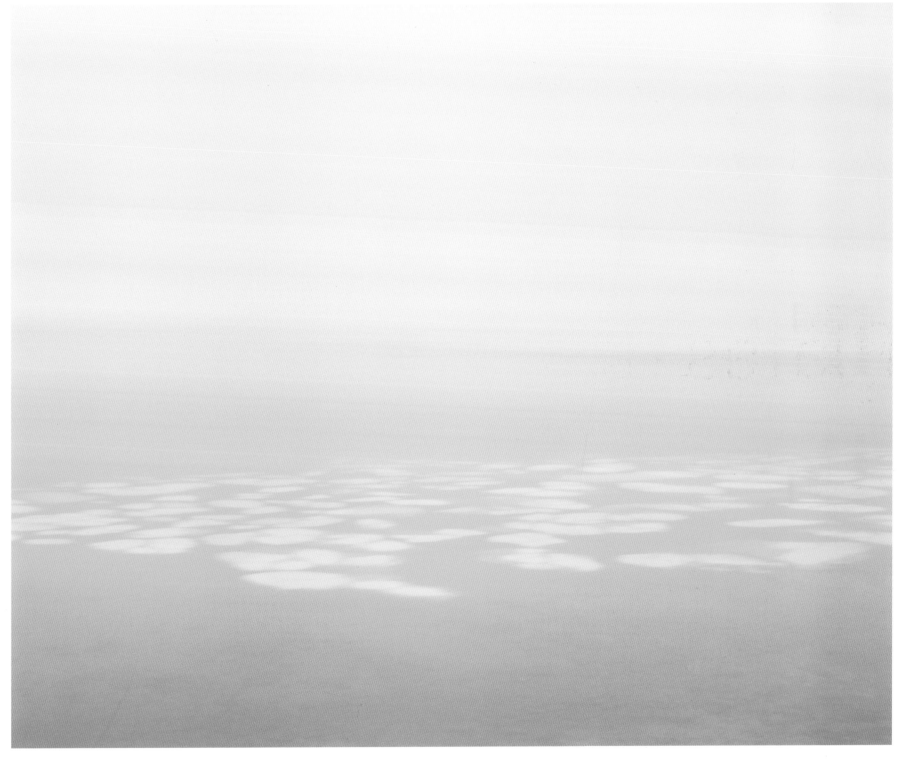

23

PLATE I

Snowstorm Sugar Pine Point State Park

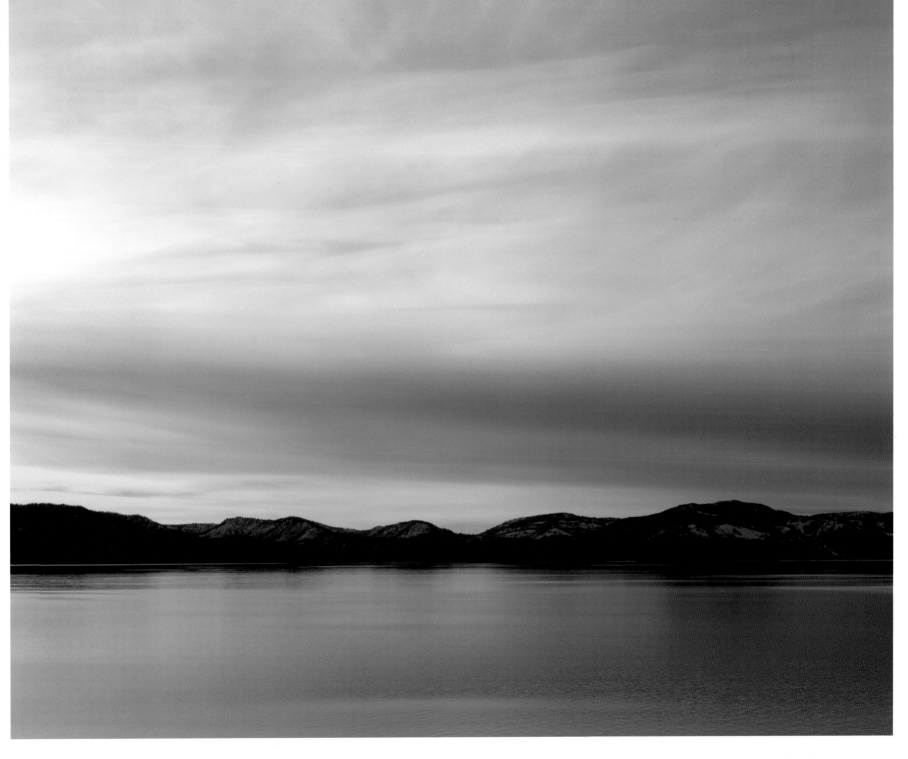

25

PLATE 2

Sunset Logan Shoals

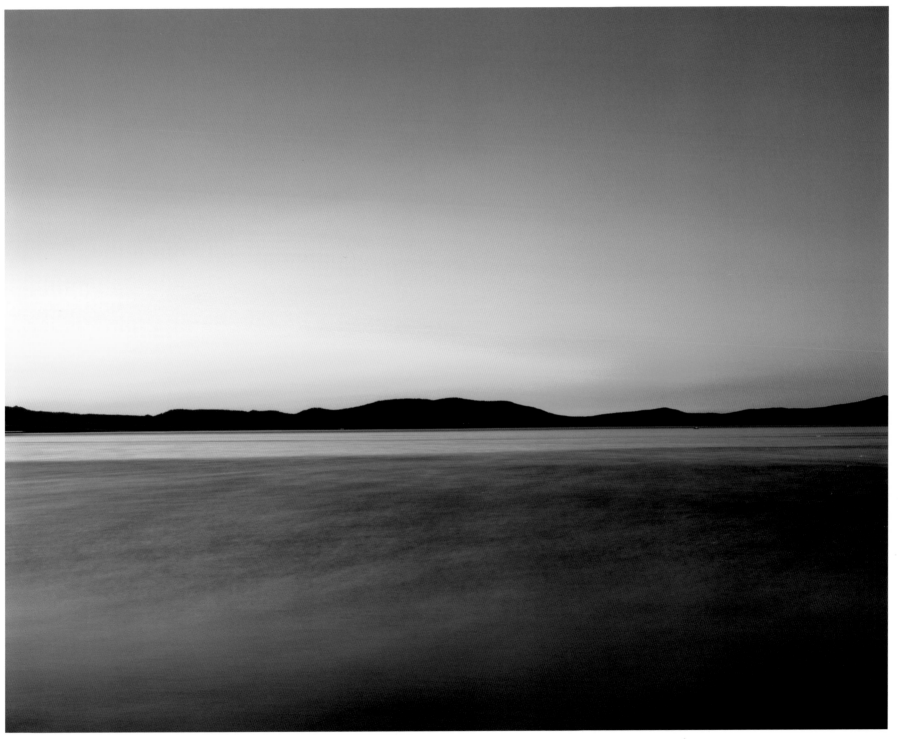

PLATE 3 Twilight Valhalla Camp Richardson

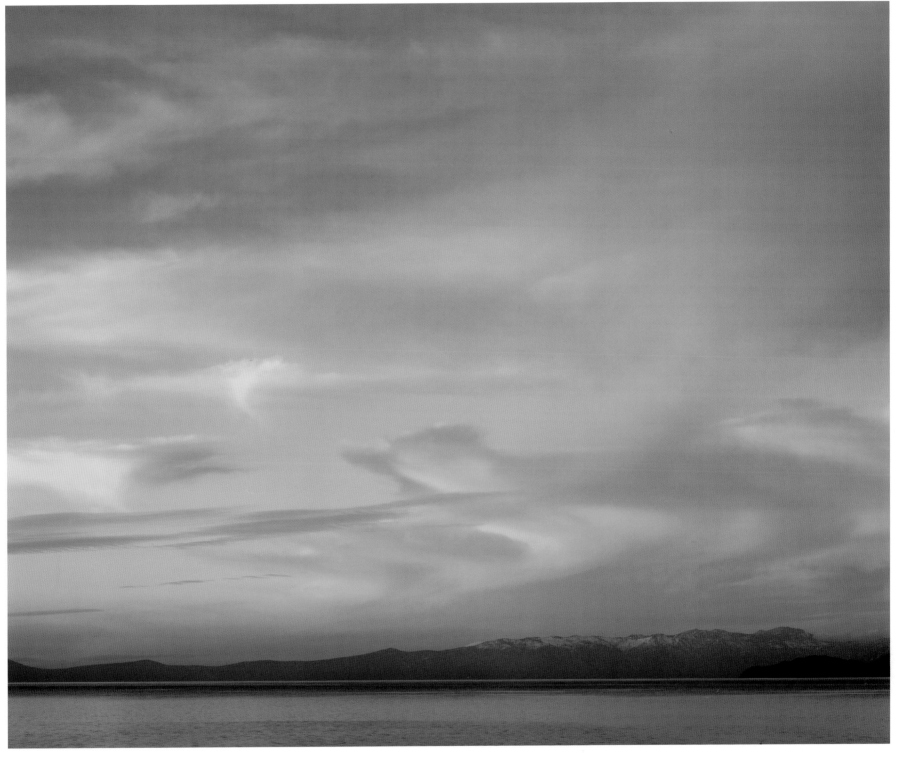

PLATE 4 Sunset Stateline

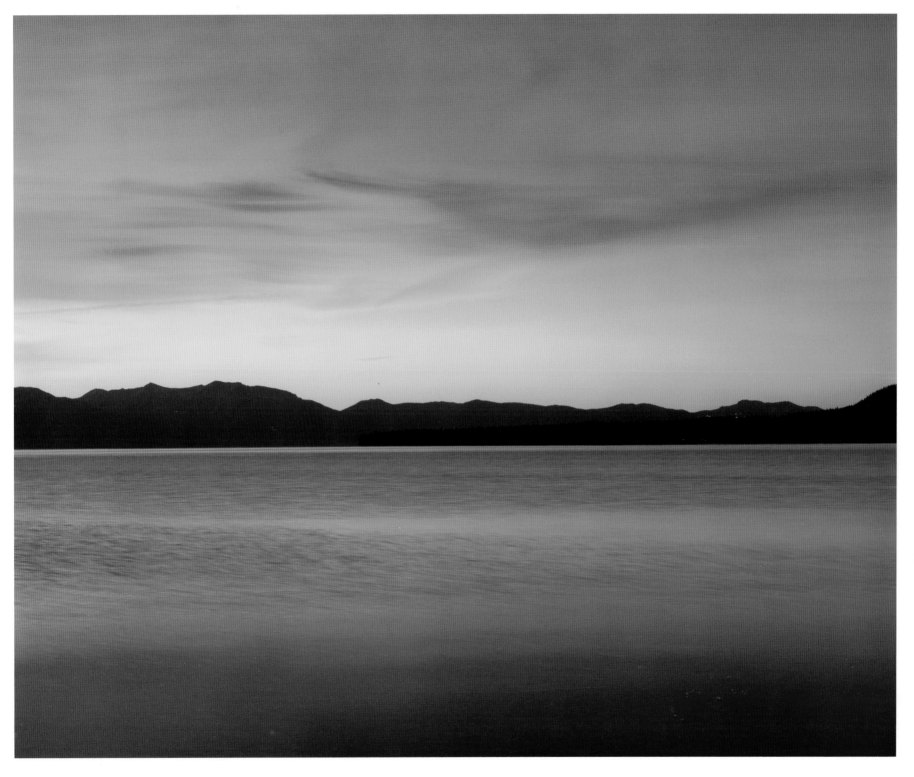

PLATE 5 Dawn Kaspian

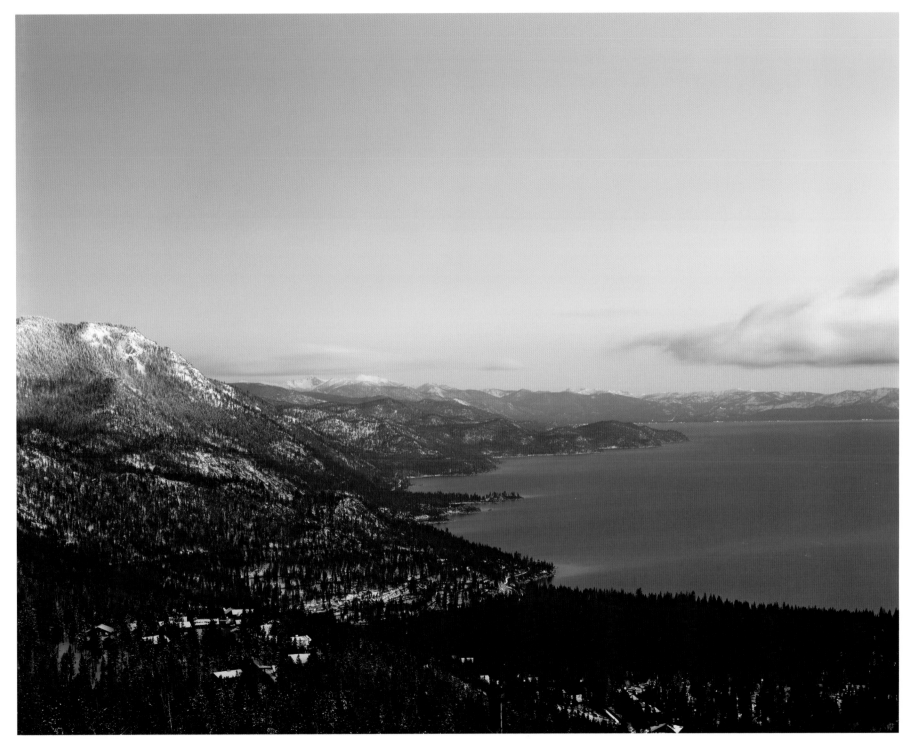

33

PLATE 6

Herlan Peak and east shore Incline Village

PLATE 7 Lenticulars Sugar Pine Point State Park

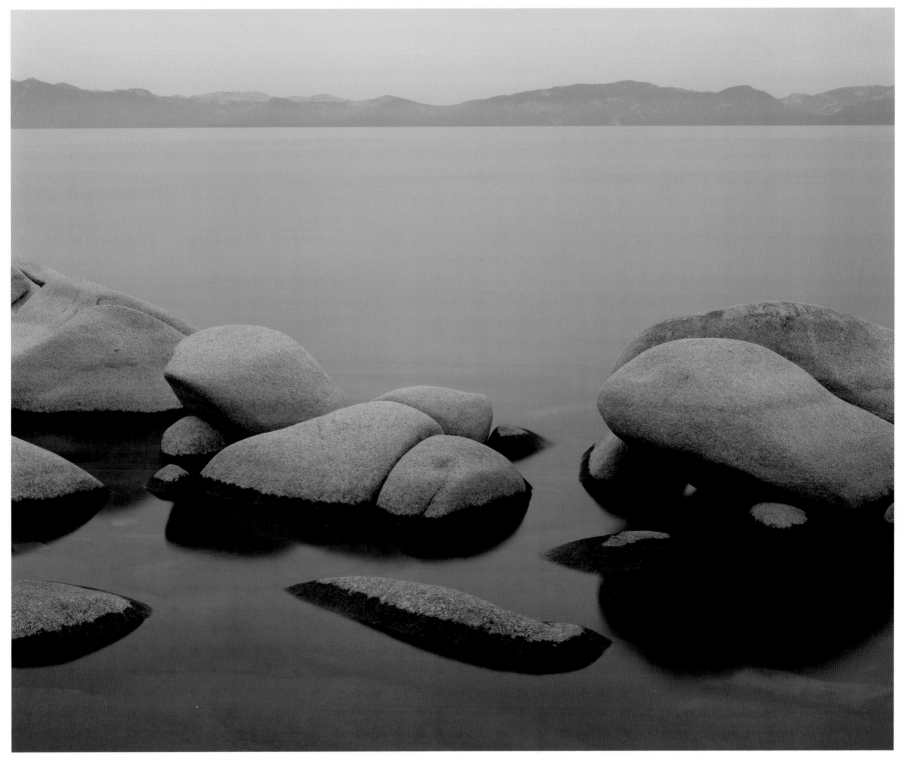

PLATE 8

First light Lake Tahoe–Nevada State Park

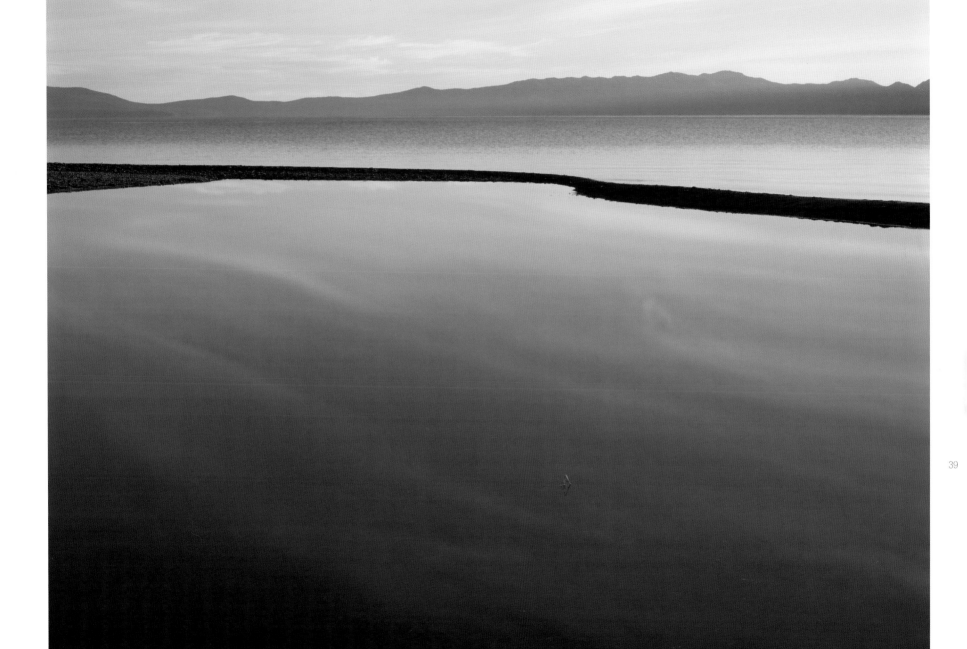

39

PLATE 9

Mouth of Taylor Creek Baldwin Beach

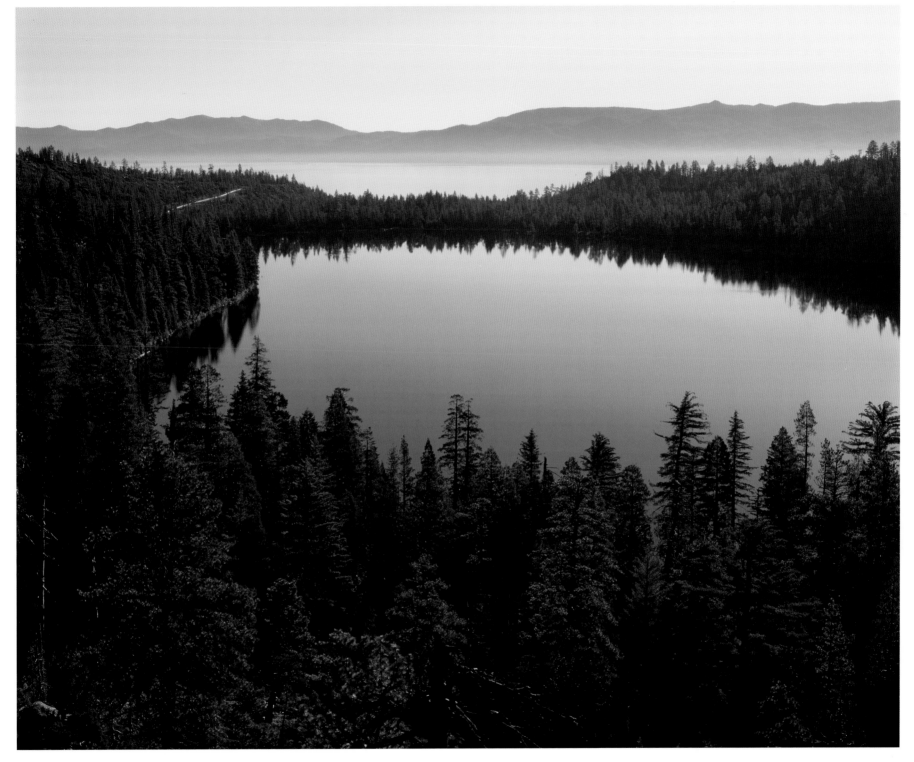

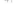

PLATE IO

Cascade Lake and Lake Tahoe Cascade Lake

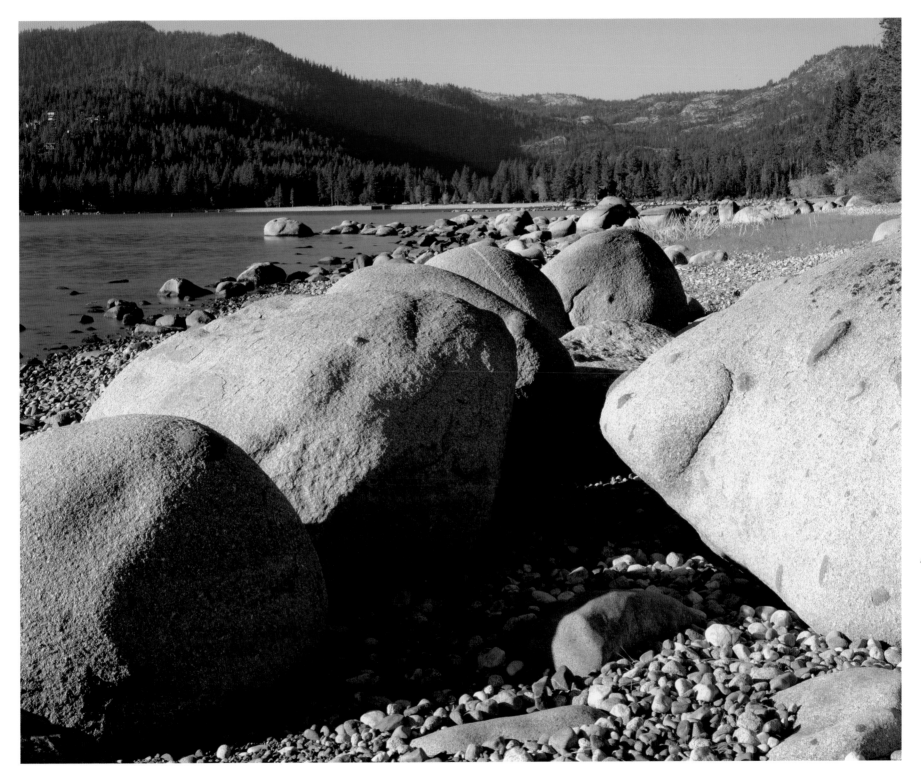

43

PLATE II

Granite boulders Sugar Pine Point State Park

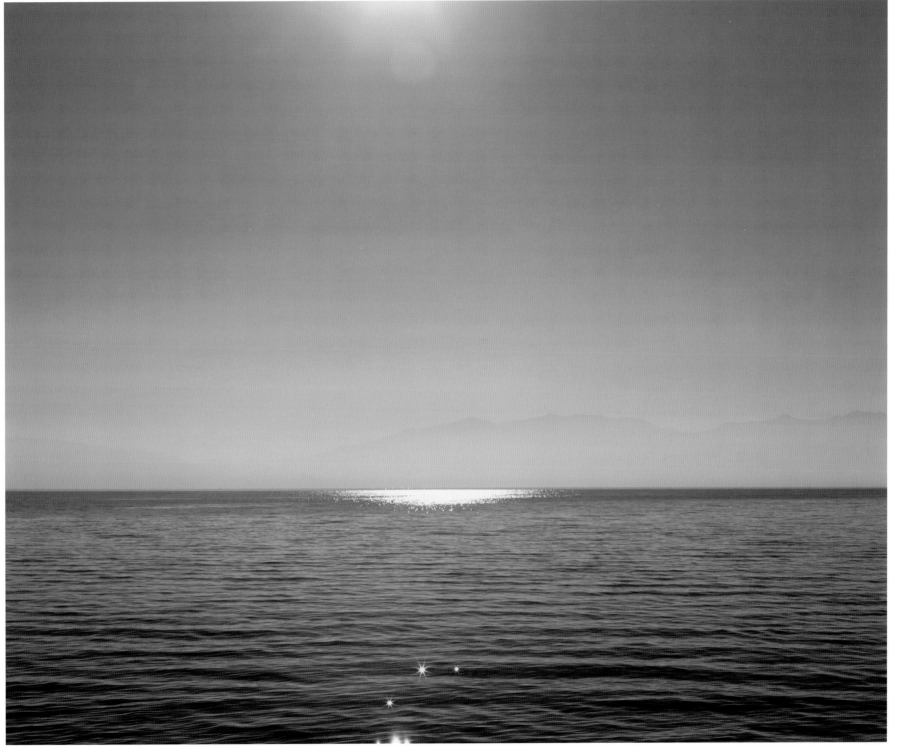

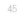

PLATE 12 Specular Sugar Pine Point State Park

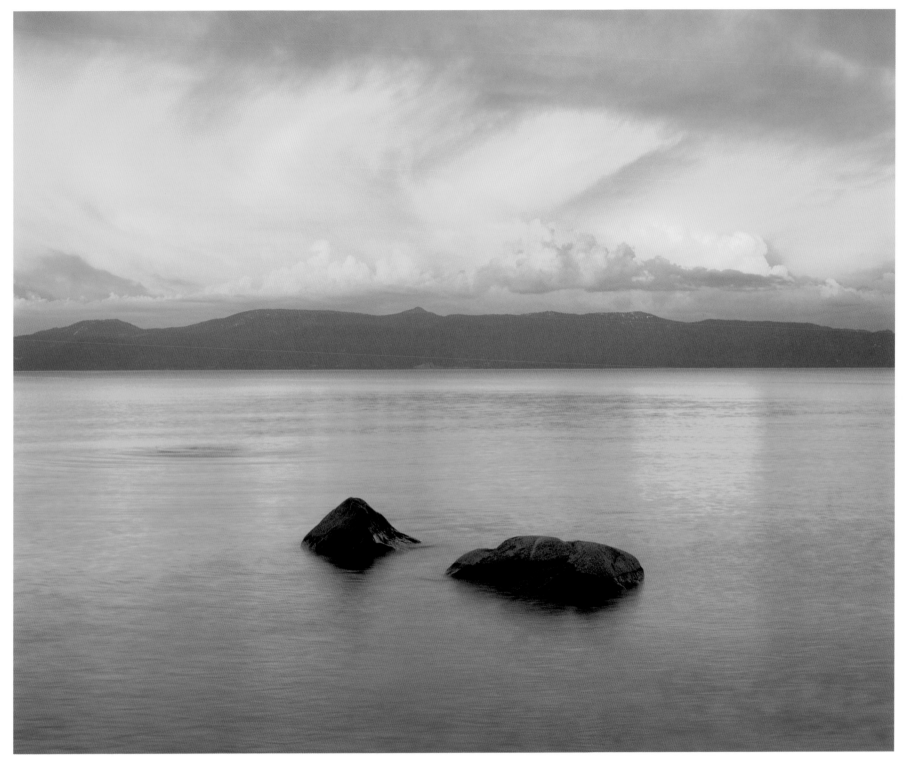

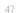

PLATE 13 Two rocks Sugar Pine Point State Park

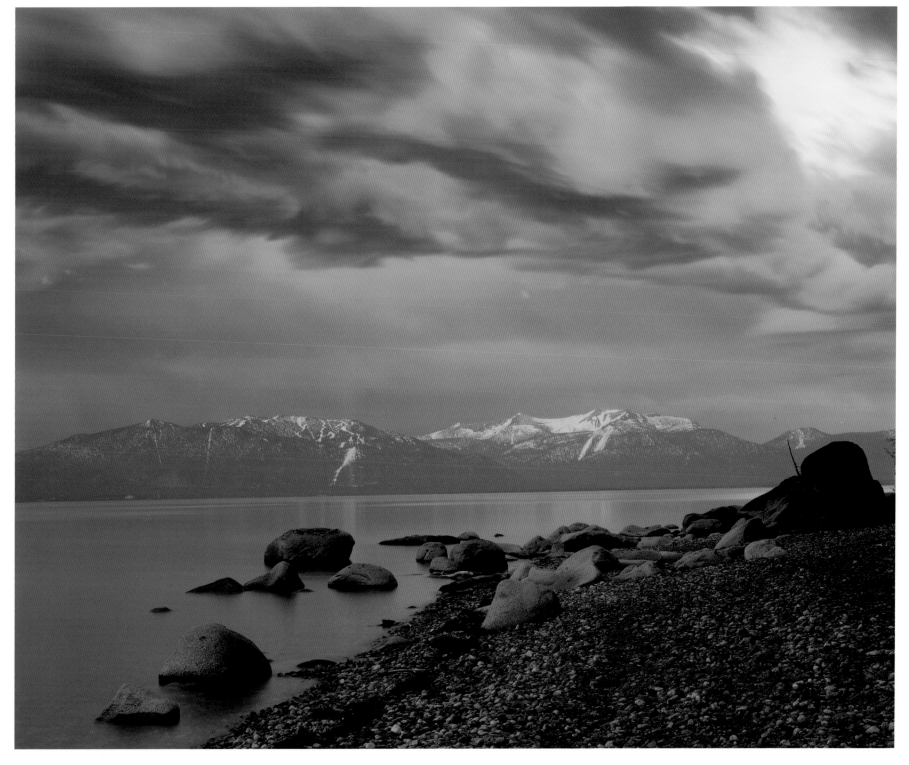

PLATE 14 Sunset storm Sugar Pine Point State Park

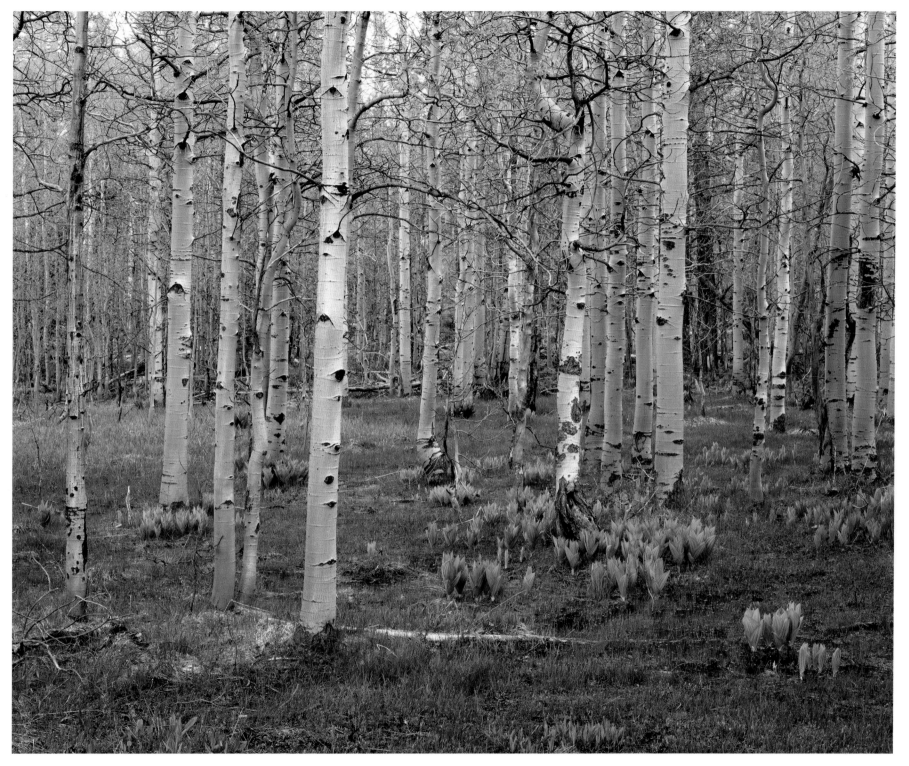

PLATE 15 Aspen forest Tallac Creek Watershed

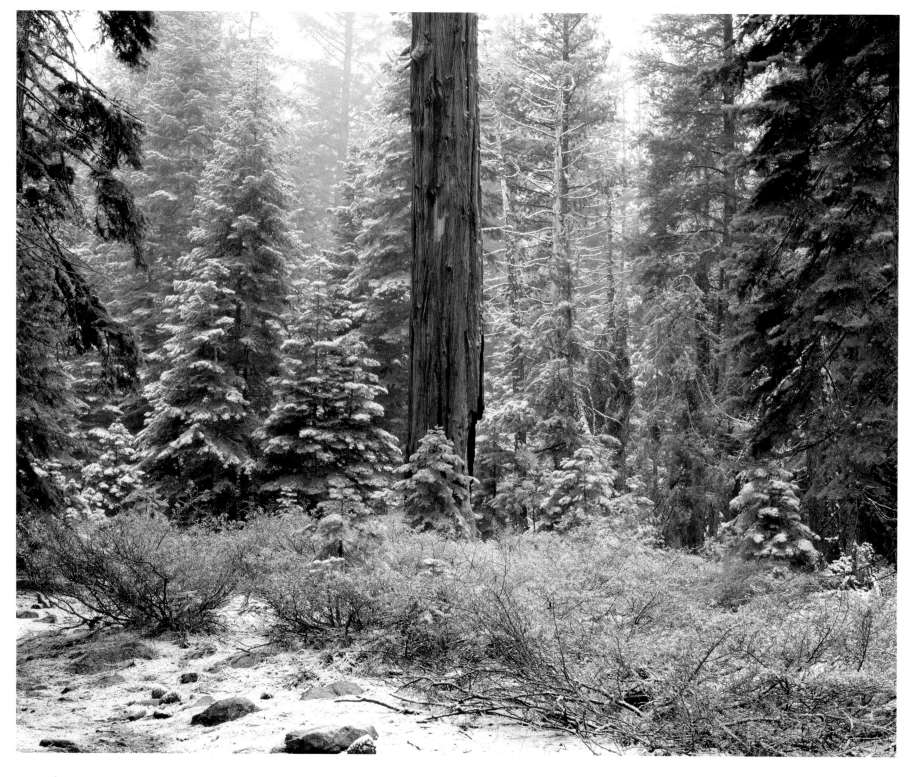

PLATE 16 Cedar Sugar Pine Point State Park

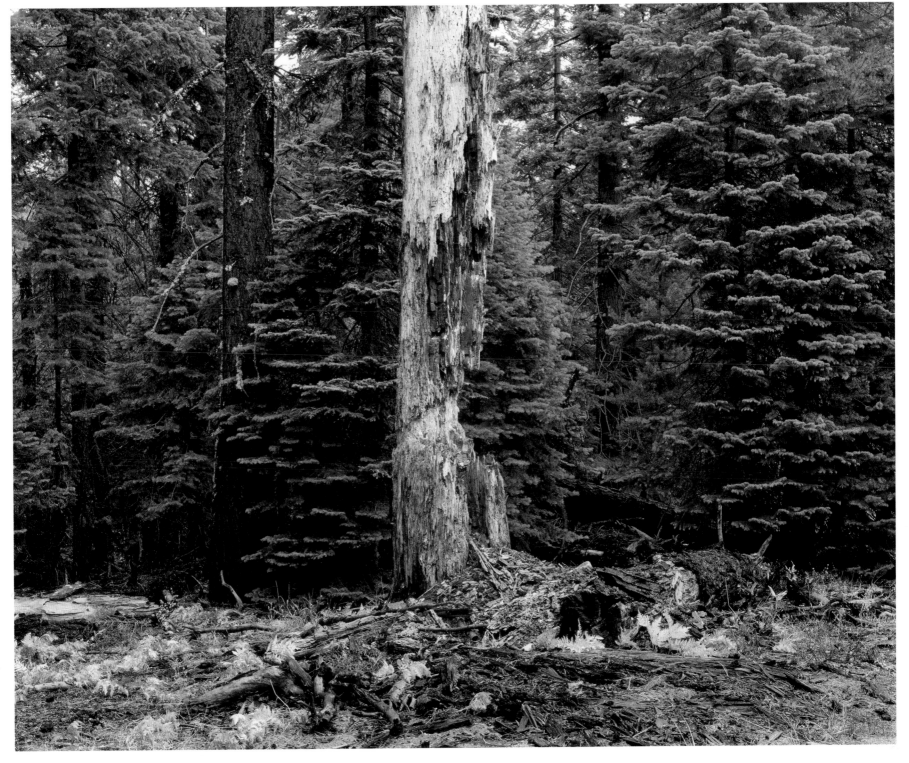

PLATE 17

Decay Sugar Pine Point State Park

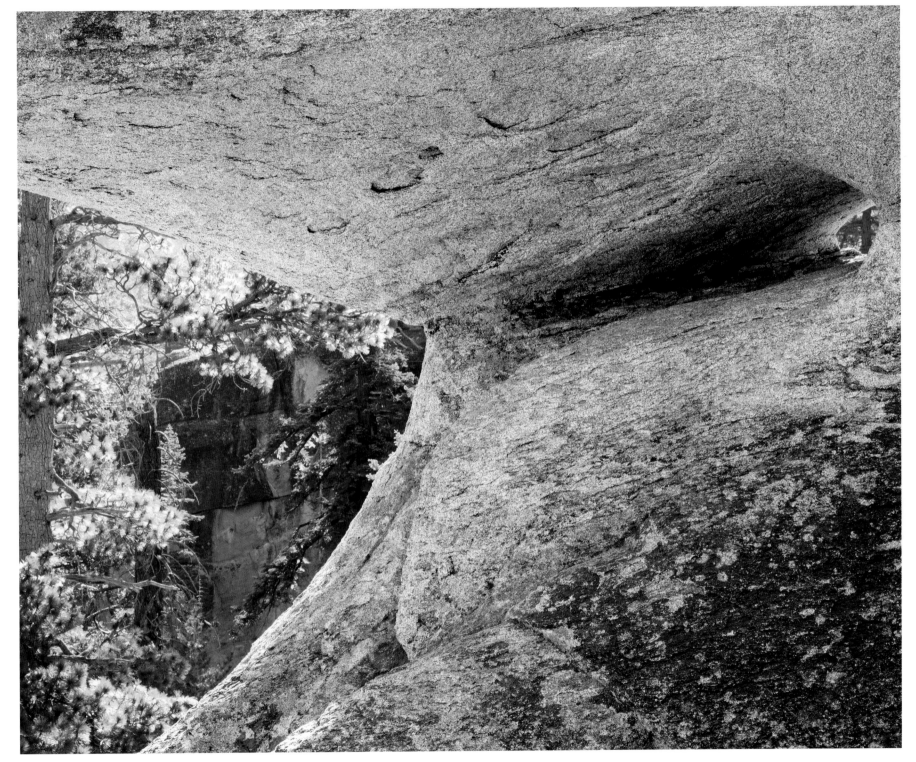

PLATE 18 Balancing Rock D. L. Bliss State Park

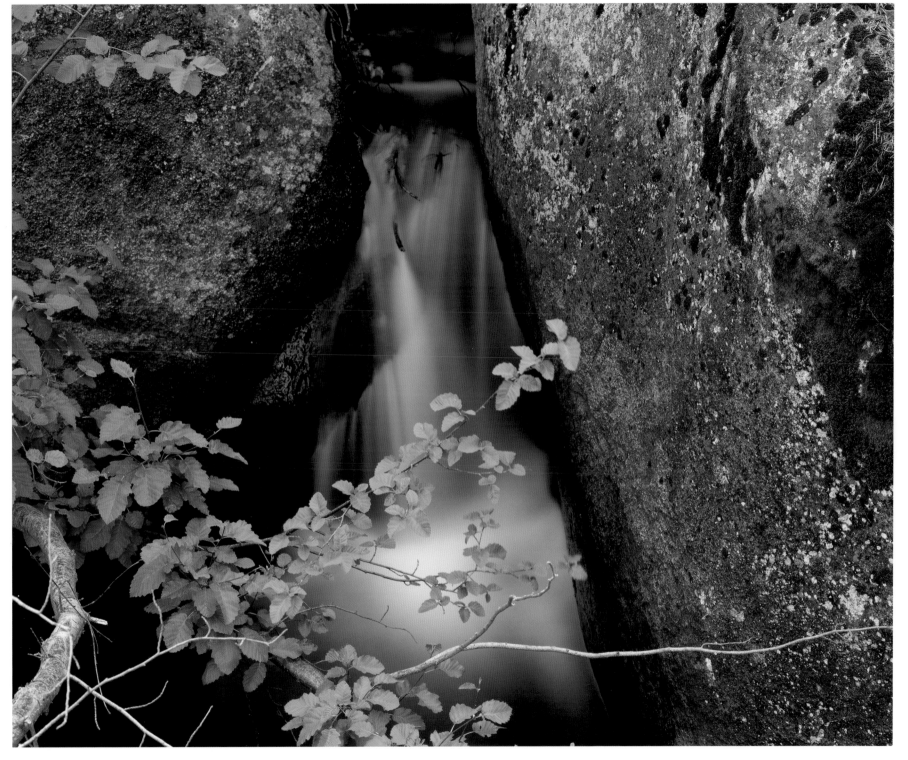

PLATE 19 Waterfall D. L. Bliss State Park

58

PLATE 20

Golden grasses in the
Truckee Marsh

South Lake Tahoe

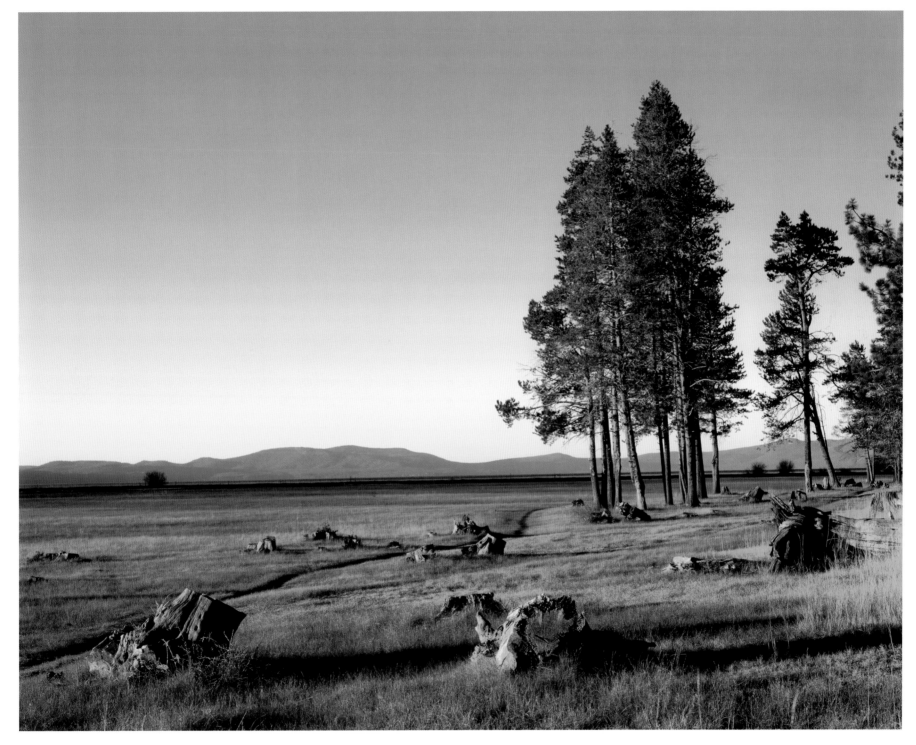

PLATE 21

Shadow light upon the
Truckee Marsh

South Lake Tahoe

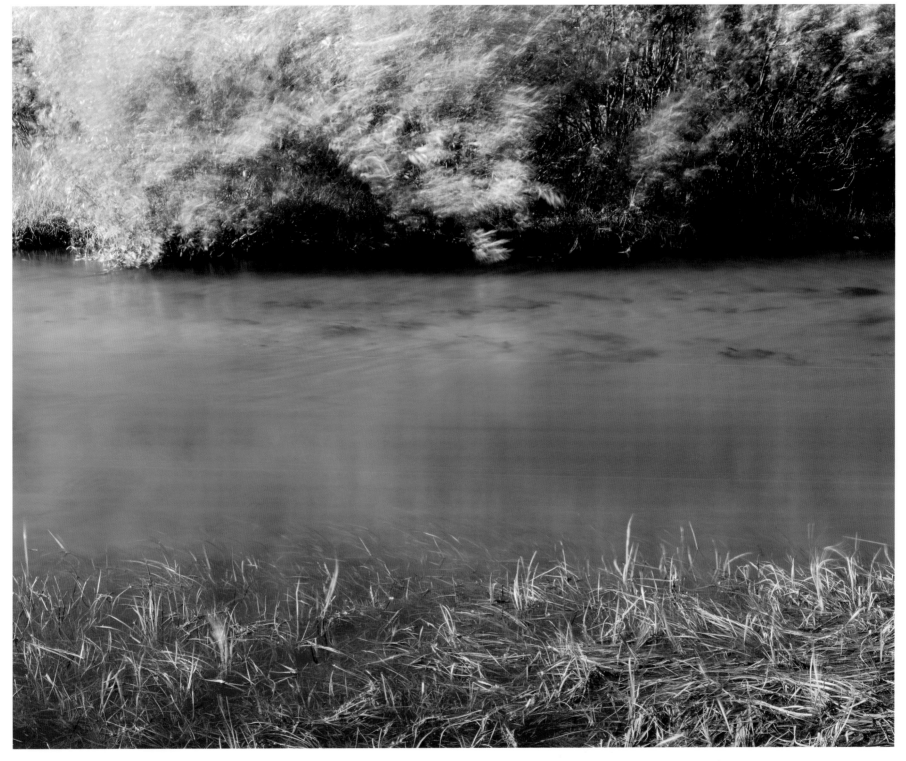

PLATE 22

Trout Creek in the
Truckee Marsh

South Lake Tahoe

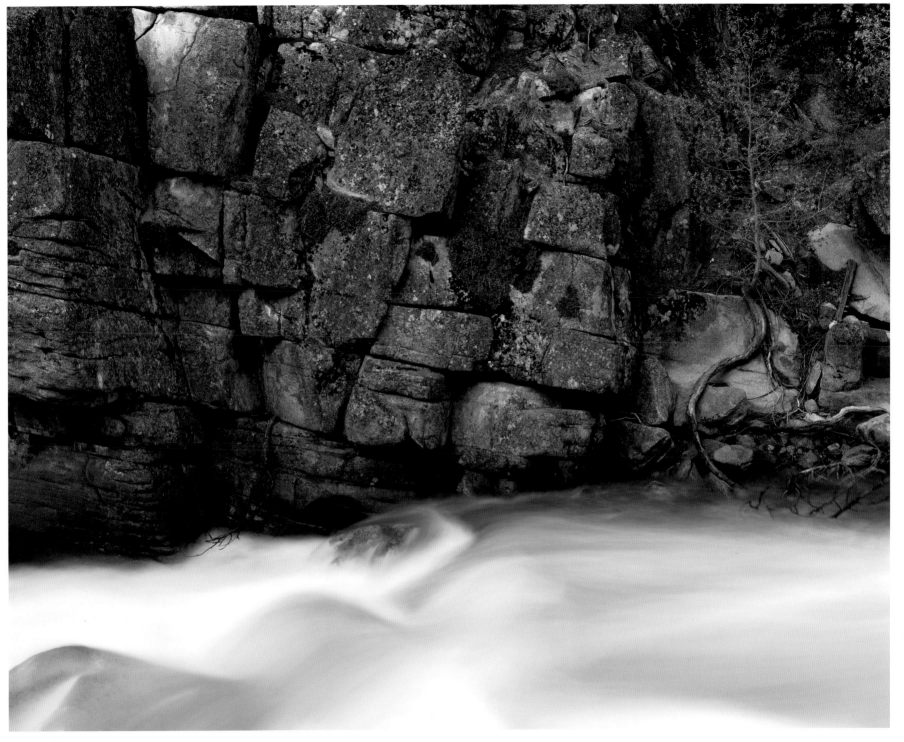

PLATE 23 Carson River West Carson Canyon

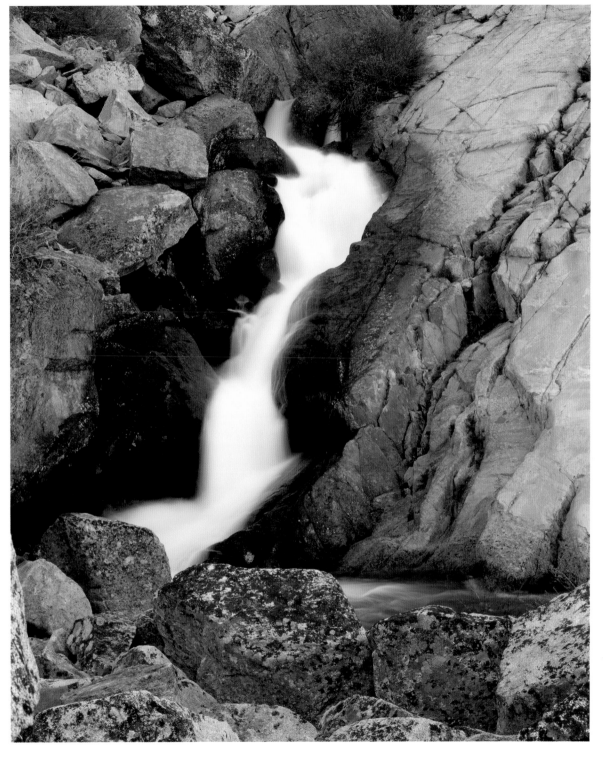

PLATE 24 Cascade Creek Desolation Wilderness

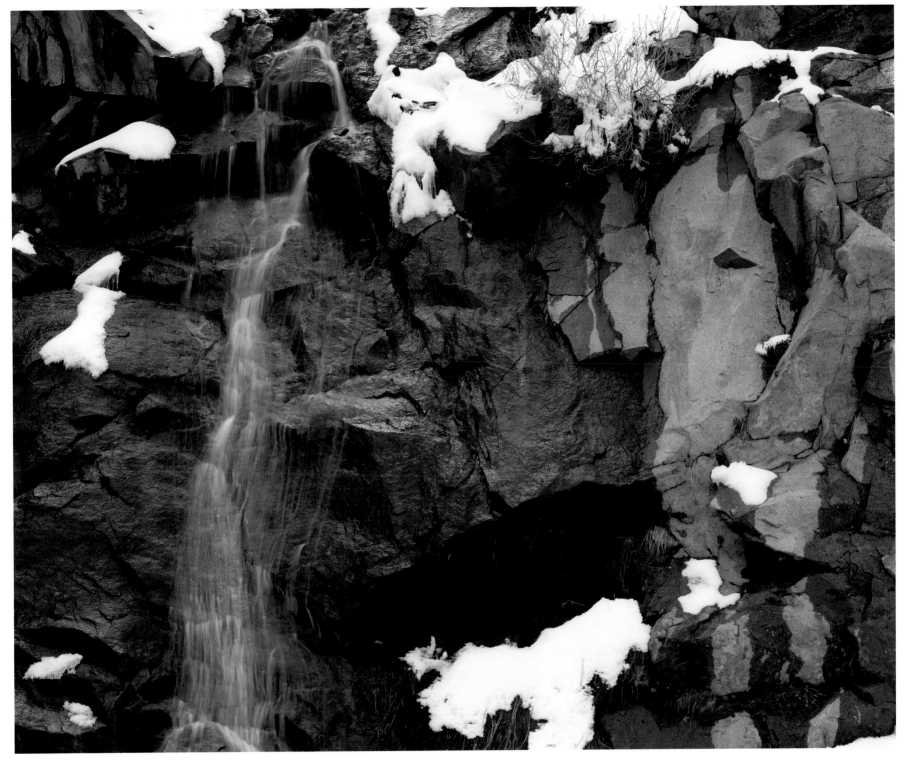

PLATE 25

Spring waterfall Emerald Bay State Park

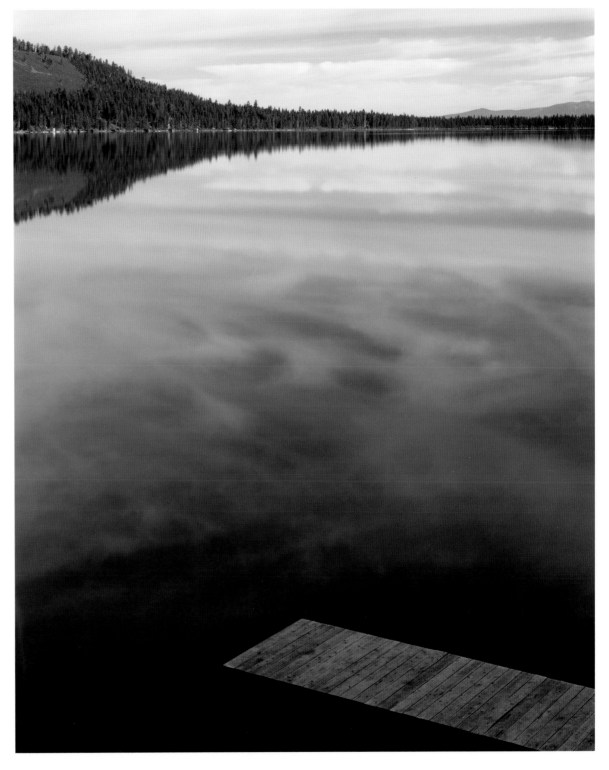

PLATE 26 Pier Fallen Leaf Lake

Roughing It Chapter 22

Mark Twain

Photography by Carleton Watkins

It was the end of August, and the skies were cloudless and the weather superb. In two or three weeks I had grown wonderfully fascinated with the curious new country, and concluded to put off my return to "the States" a while. I had grown well accustomed to wearing a damaged slouch hat, blue woolen shirt, and pants crammed into boot-tops, and gloried in the absence of coat, vest, and braces. I felt rowdy-ish and "bully" (as the historian Josephus phrases it, in his fine chapter upon the destruction of the Temple). It seemed to me that nothing could be so fine and so romantic. I had become an officer of the government, but that was for mere sublimity. The office was an unique sinecure. I had nothing to do and no salary. I was private secretary to his majesty the Secretary and there was not yet writing enough for two of us. So Johnny K—— and I devoted our time to amusement. He was the young son of an Ohio nabob and was out there for recreation. He got it. We had heard a world of talk about the marvelous beauty of Lake Tahoe, and finally curiosity drove us thither to see it. Three or four members of the Brigade had been there and located some timber lands on its shores and stored up a quantity of provisions in their camp. We strapped a couple of blankets on our shoulders and took an

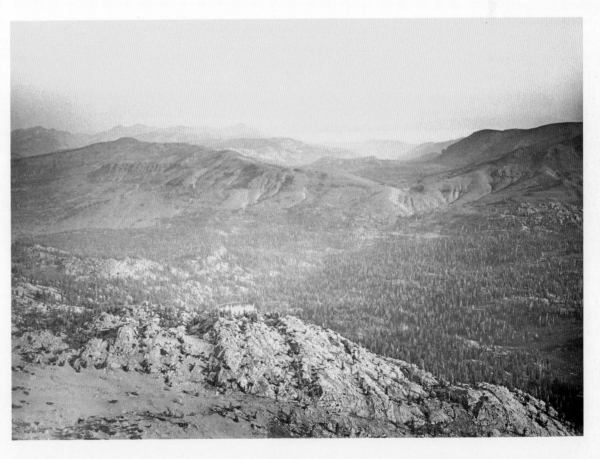

71

WATKINS A

View from Round Top. Looking westward. Pyramid, Round Top Proper, Azimuth Mark in left background. Mt. Tallac in middle background. Woods Lake in foreground under it. Lake Tahoe to right of Mt. Tallac. Red Mountain and Carson Pass on extreme right

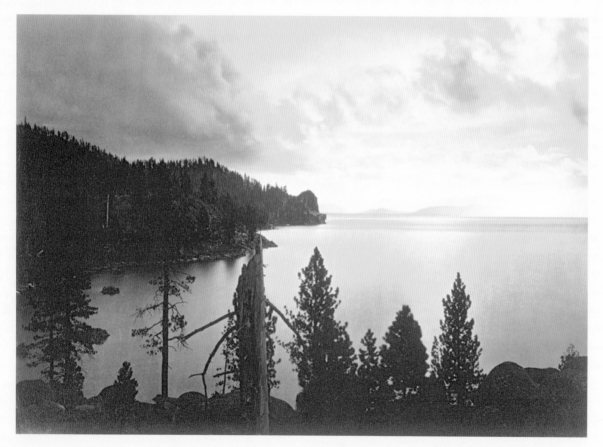

72

axe apiece and started—for we intended to take up a wood ranch or so ourselves and become wealthy. We were on foot. The reader will find it advantageous to go horseback. We were told that the distance was eleven miles. We tramped a long time on level ground, and then toiled laboriously up a mountain about a thousand miles high and looked over. No lake there. We descended on the other side, crossed the valley and toiled up another mountain three or four thousand miles high, apparently, and looked over again. No lake yet. We sat down tired and perspiring, and hired a couple of Chinamen to curse those people who had beguiled us. Thus refreshed, we presently resumed the march with renewed vigor and determination. We plodded on, two or three hours longer, and at last the Lake burst upon us—a noble sheet of blue water lifted six thousand three hundred feet above the level of the sea, and walled in by a rim of snow-clad mountain peaks that towered aloft full three thousand feet higher still! It was a vast oval, and one would have to use up eighty or a hundred good miles in traveling around it. As it lay there with the shadows of the mountains brilliantly photographed upon its still surface I thought it must surely be the fairest picture the whole earth affords.

WATKINS B A Storm on Lake Tahoe

We found the small skiff belonging to the Brigade boys, and without loss of time set out across a deep bend of the lake toward the landmarks that signified the locality of the camp. I got Johnny to row—not because I mind exertion myself, but because it makes me sick to ride backwards when I am at work. But I steered. A three-mile pull brought us to the camp just as the night fell, and we stepped ashore very tired and wolfishly hungry. In a "cache" among the rocks we found the provisions and the cooking utensils, and then, all fatigued as I was, I sat down on a boulder and superintended while Johnny gathered wood and cooked supper. Many a man who had gone through what I had, would have wanted to rest.

It was a delicious supper—hot bread, fried bacon, and black coffee. It was a delicious solitude we were in, too. Three miles away was a saw-mill and some workmen, but there were not fifteen other human beings throughout the wide circumference of the lake. As the darkness closed down and the stars came out and spangled the great mirror with jewels, we smoked meditatively in the solemn hush and forgot our troubles and our pains. In due time we spread our blankets in the warm sand between two large

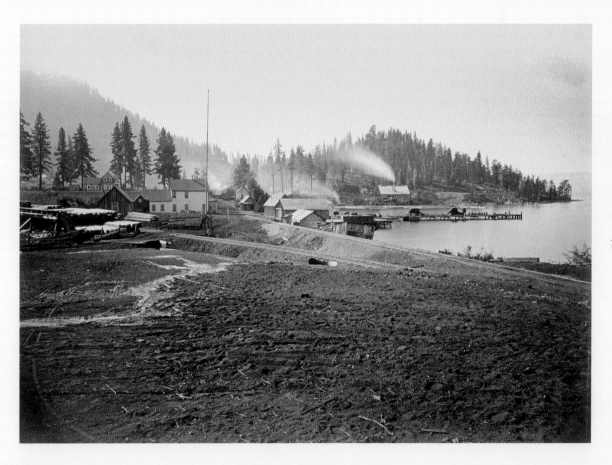

73

WATKINS C

Glenbrook, Lake Tahoe

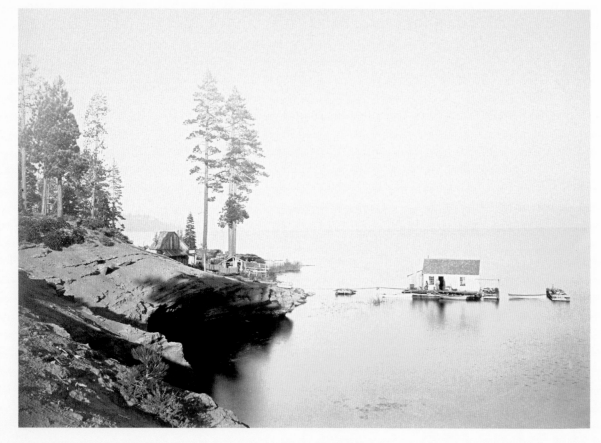

boulders and soon feel asleep, careless of the procession of ants that passed in through rents in our clothing and explored our persons. Nothing could disturb the sleep that fettered us, for it had been fairly earned, and if our consciences had any sins on them they had to adjourn court for that night, anyway. The wind rose just as we were losing consciousness, and we were lulled to sleep by the beating of the surf upon the shore.

It is always very cold on that lake shore in the night, but we had plenty of blankets and were warm enough. We never moved a muscle all night, but waked at early dawn in the original positions, and got up at once, thoroughly refreshed, free from soreness, and brim full of friskiness. There is no end of wholesome medicine in such an experience. That morning we could have whipped ten such people as we were the day before—sick ones at any rate. But the world is slow, and people will go to "water cures" and "movement cures" and to foreign lands for health. Three months of camp life on Lake Tahoe would restore an Egyptian mummy to his pristine vigor, and give him an appetite like an alligator. I do not mean the oldest and driest mummies, of course, but the fresher ones. The air up there in the

WATKINS D

Lake Tahoe,
View from Tahoe City

clouds is very pure and fine, bracing and delicious. And why shouldn't it be?—it is the same the angels breathe. I think that hardly any amount of fatigue can be gathered together that a man cannot sleep off in one night on the sand by its side. Not under a roof, but under the sky; it seldom or never rains there in the summer time. I know a man who went there to die. But he made a failure of it. He was a skeleton when he came, and could barely stand. He had no appetite, and did nothing but read tracts and reflect on the future. Three months later he was sleeping out of doors regularly, eating all he could hold, three times a day, and chasing game over mountains three thousand feet high for recreation. And he was a skeleton no longer, but weighed part of a ton. This is no fancy sketch, but the truth. His disease was consumption. I confidently commend his experience to other skeletons.

I superintended again, and as soon as we had eaten breakfast we got in the boat and skirted along the lake shore about three miles and disembarked. We liked the appearance of the place, and so we claimed some three hundred acres of it and stuck our "notices" on a tree. It was yellow pine timber land—a dense forest of trees a hundred feet high and from one to five feet through at the butt. It was necessary to fence our property or we could not hold it. That is to say, it was necessary to cut down trees here and there and make them fall in such a way as to form a sort of enclosure (with pretty wide gaps in it). We cut down three trees apiece, and found it such heart-breaking work that we decided to "rest our case" on those; if they held the property, well and good; if they didn't, let the property spill out through the gaps and go; it was no use to work ourselves to death merely to save a few acres of land. Next day we came back to build a house—for a house was also necessary, in order to hold the property. We decided to build a substantial log-house and excite the envy of the Brigade boys; but by the time we had cut and trimmed the first log it seemed unnecessary to be so elaborate, and so we concluded to build it of saplings. However, two saplings, duly cut and trimmed, compelled recognition of the fact that a still modester architecture would satisfy the law, and so we concluded to build a "brush" house. We devoted the next day to this work, but we did so much "sitting around" and discussing, that by the middle of the afternoon we had achieved only a half-way sort of affair which one of us had to watch while the other cut brush, lest if both turned our backs we might not be able to find it again, it had such a strong family resemblance to the surrounding vegetation. But we were satisfied with it.

We were land owners now, duly seized and possessed, and within the protection of the law. Therefore we decided to take up our residence on our own domain and enjoy that large sense of independence which only such an experience can bring. Late the next afternoon, after a good long rest, we sailed away from the Brigade camp with all the provisions and cooking utensils we could carry off—borrow is the more accurate word—and just as the night was falling we beached the boat at our own landing.

Plates 27–52

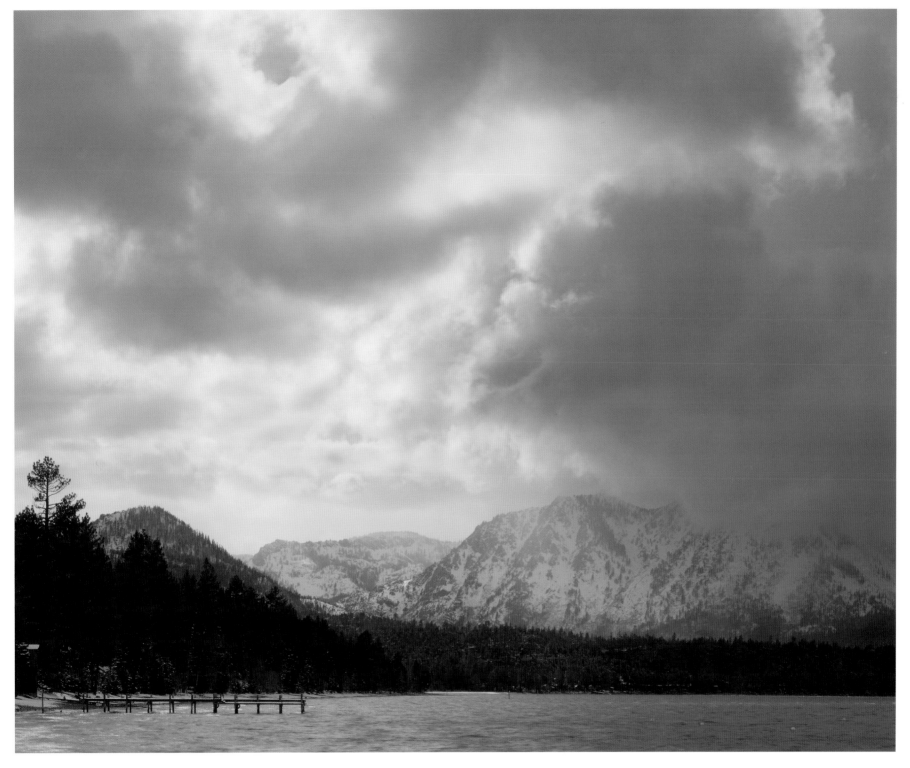

PLATE 27 Tallac in storm Camp Richardson

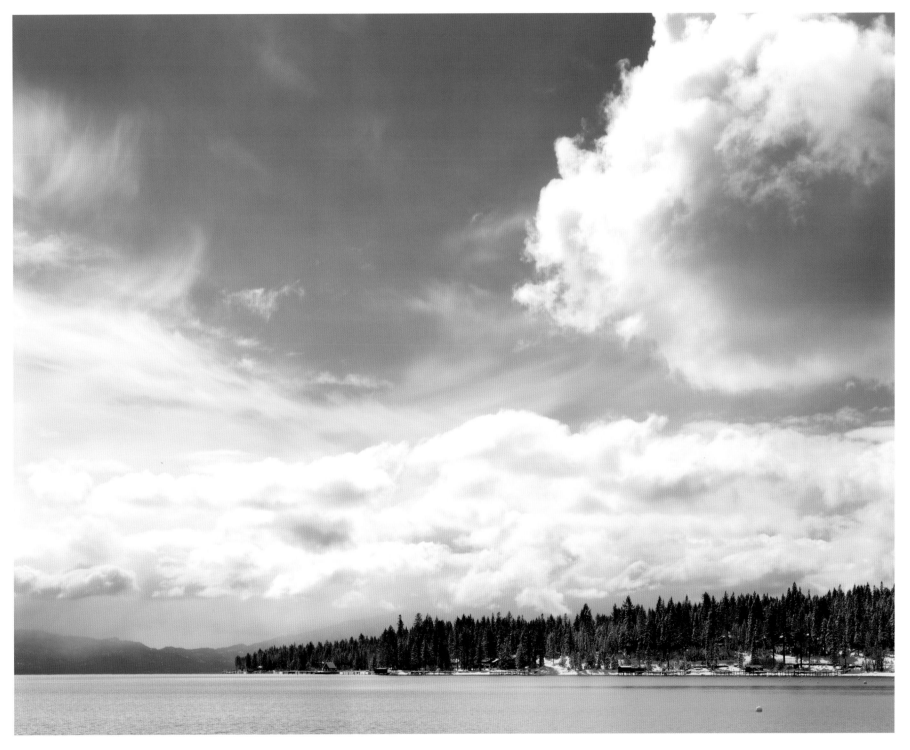

PLATE 28

Clearing winter storm Chambers Landing

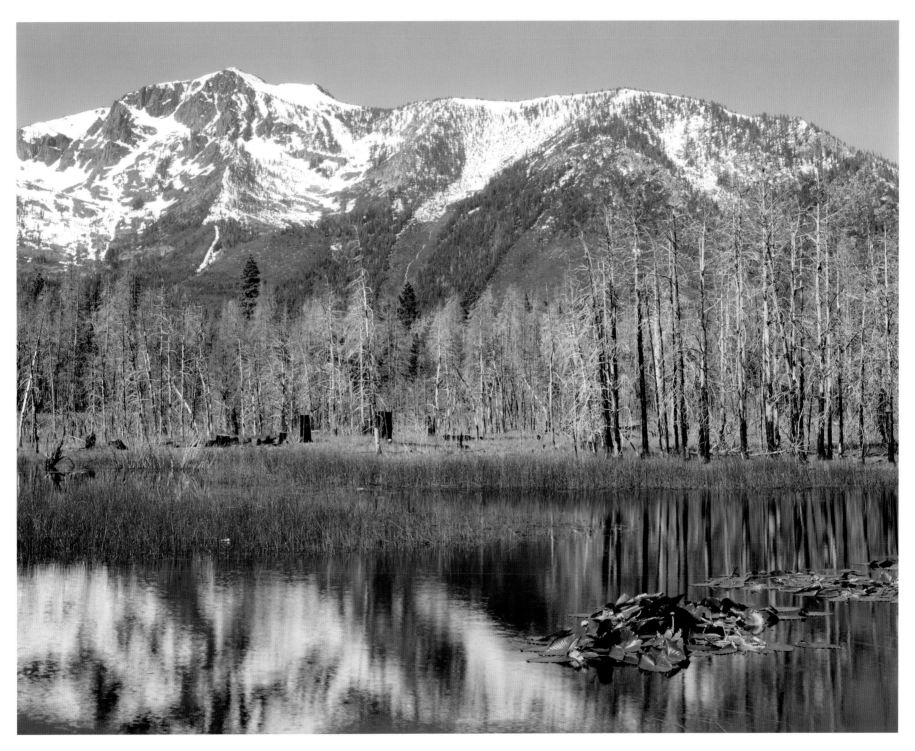

81

PLATE 29

Tallac Creek Baldwin Beach

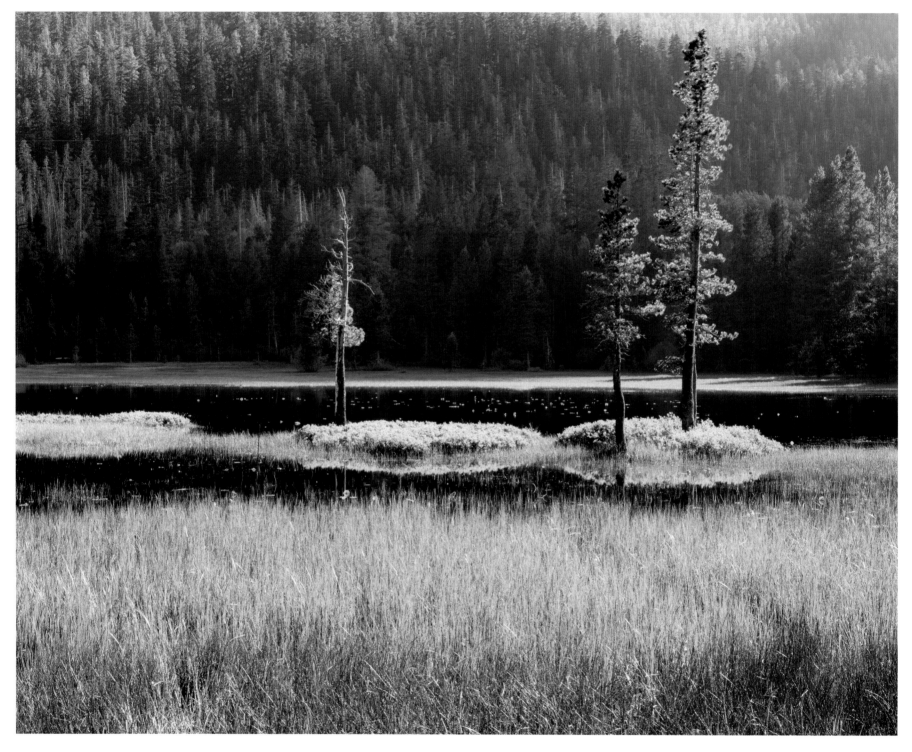

82

PLATE 30

Grass Lake Luther Pass

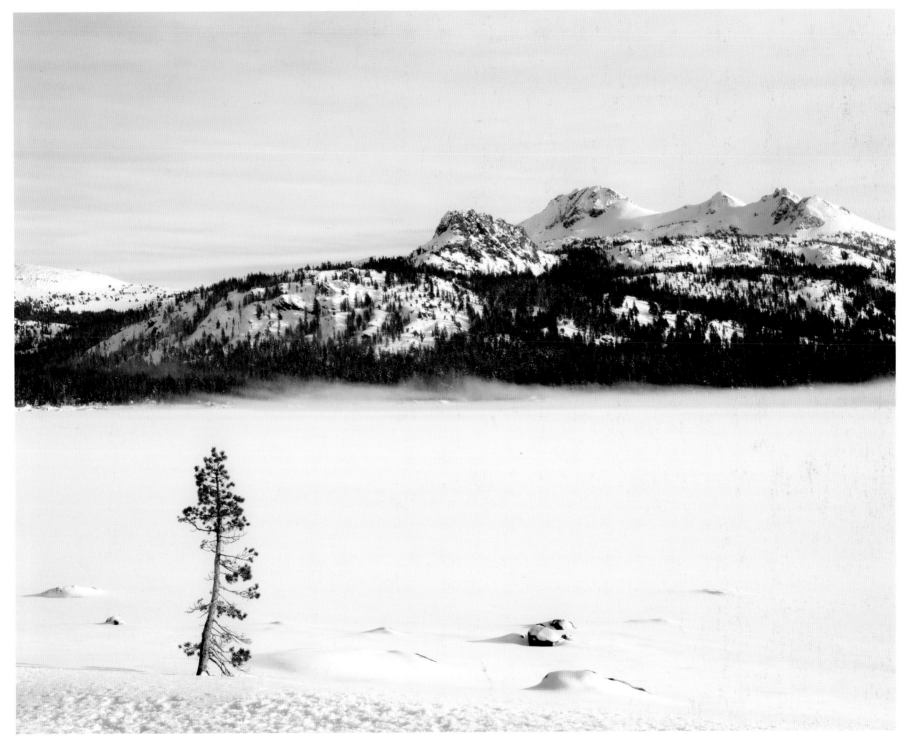

PLATE 31

Lone pine in winter Silver Lake

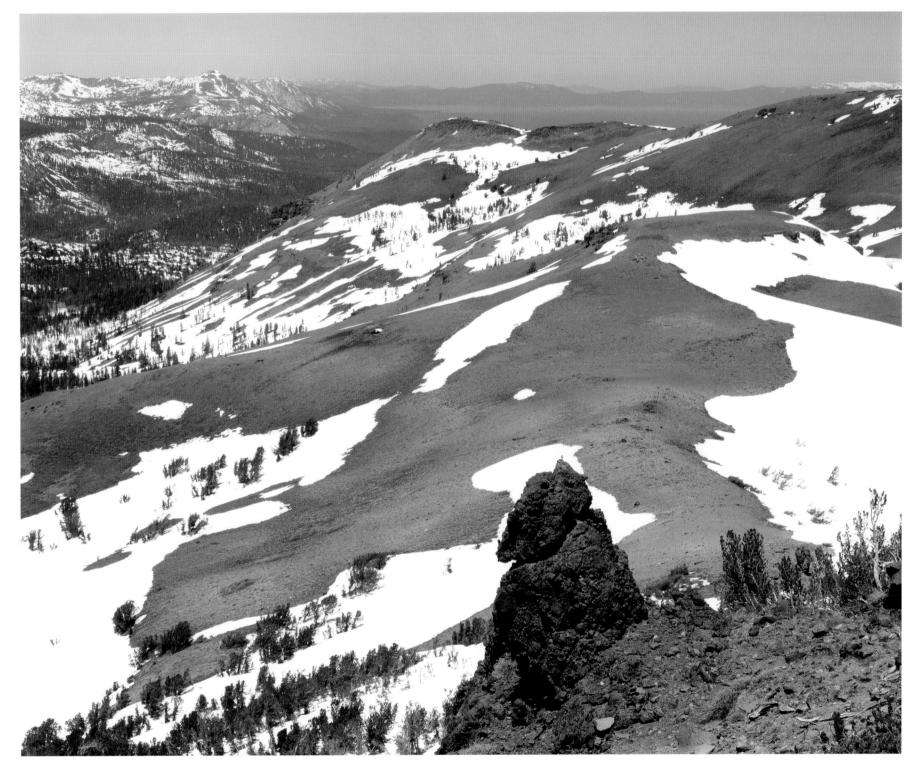

85

PLATE 32

Frémont's vantage from Carson Pass
Red Lake Peak

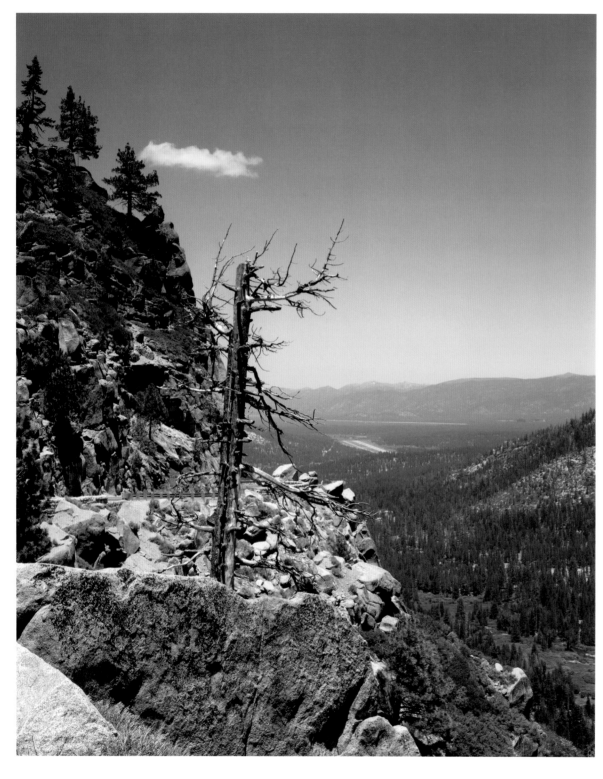

86

PLATE 33

Snag

Echo Summit

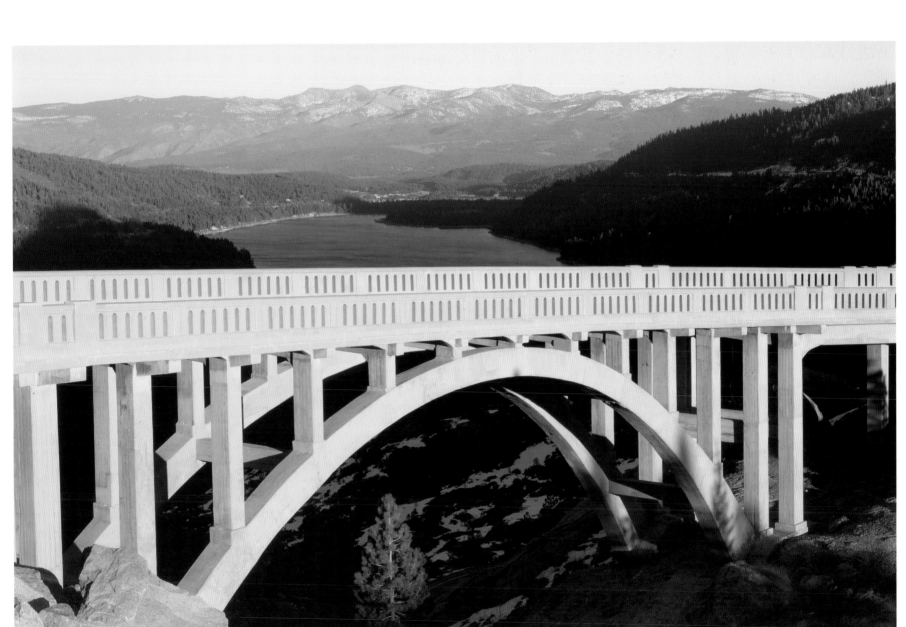

PLATE 34

Donner Summit Bridge Donner Pass

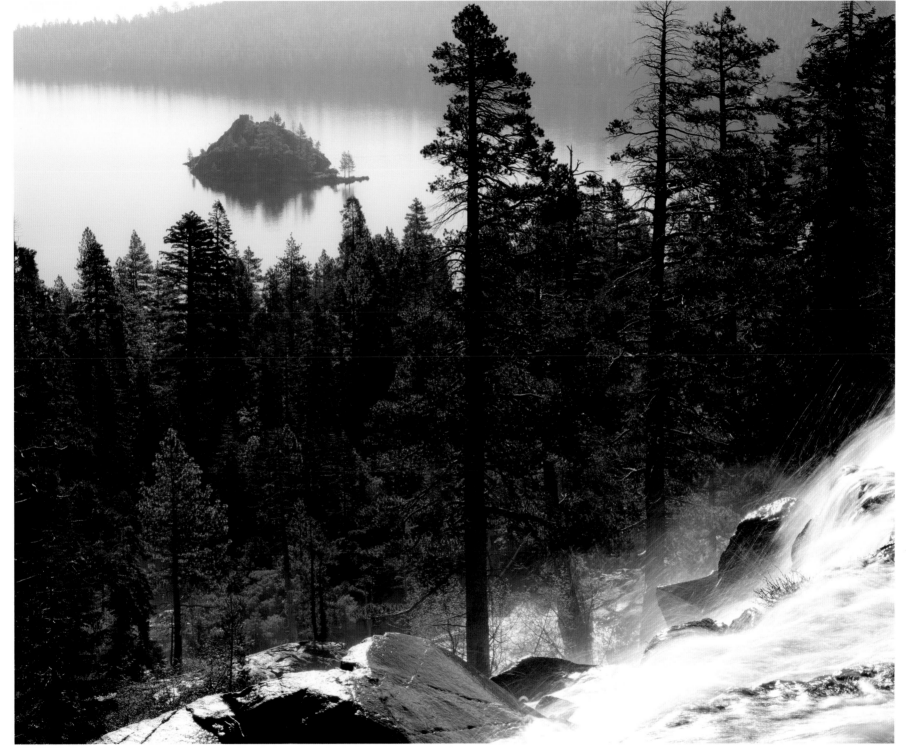

PLATE 35

Eagle Falls and Fannette Island Emerald Bay State Park

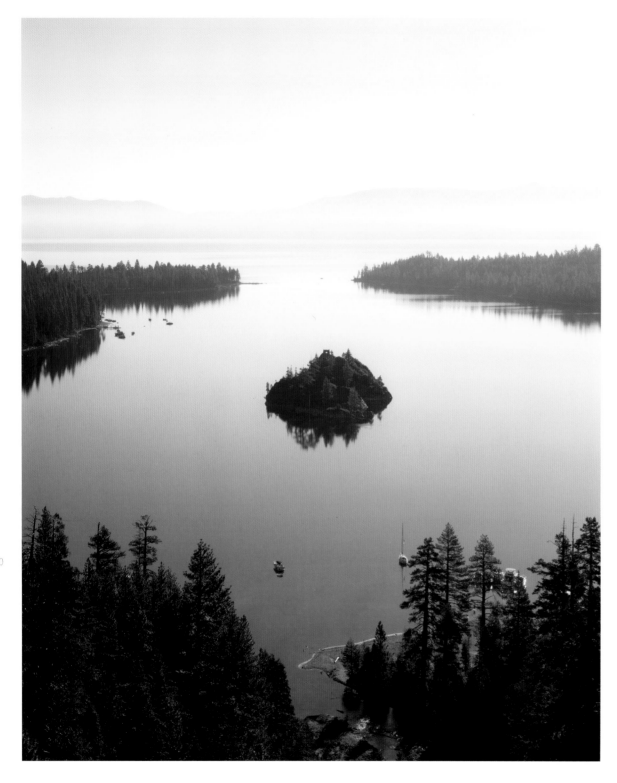

PLATE 36 Morning calm Emerald Bay State Park

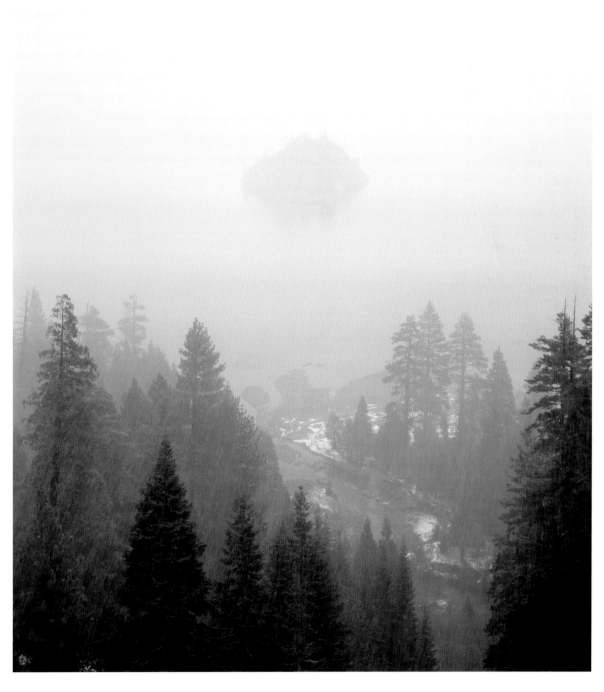

PLATE 37 Snowstorm Emerald Bay State Park

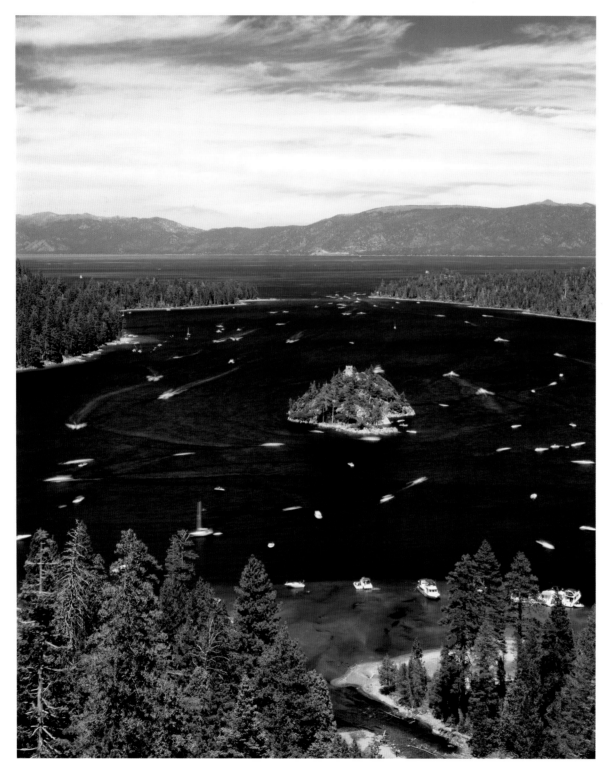

92

PLATE 38

Three seconds on the
Fourth of July

Emerald Bay State Park

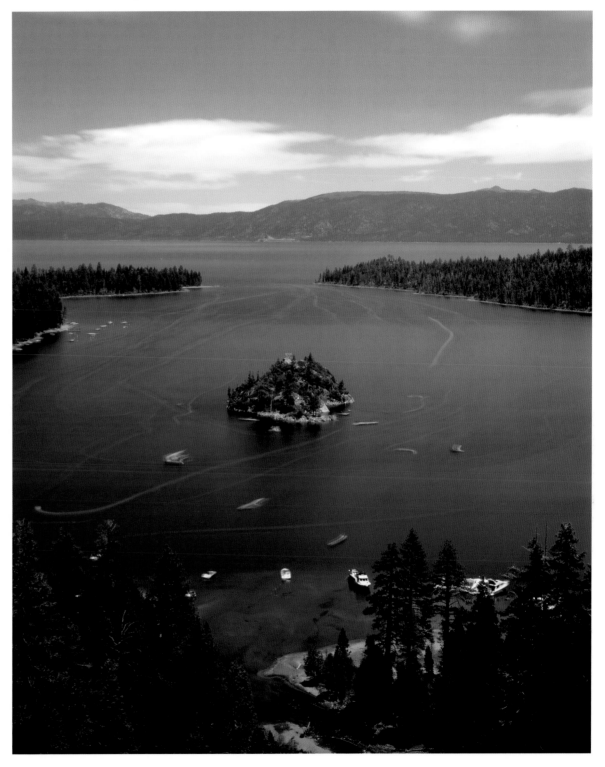

PLATE 39

Three minutes on the
Fourth of July

Emerald Bay State Park

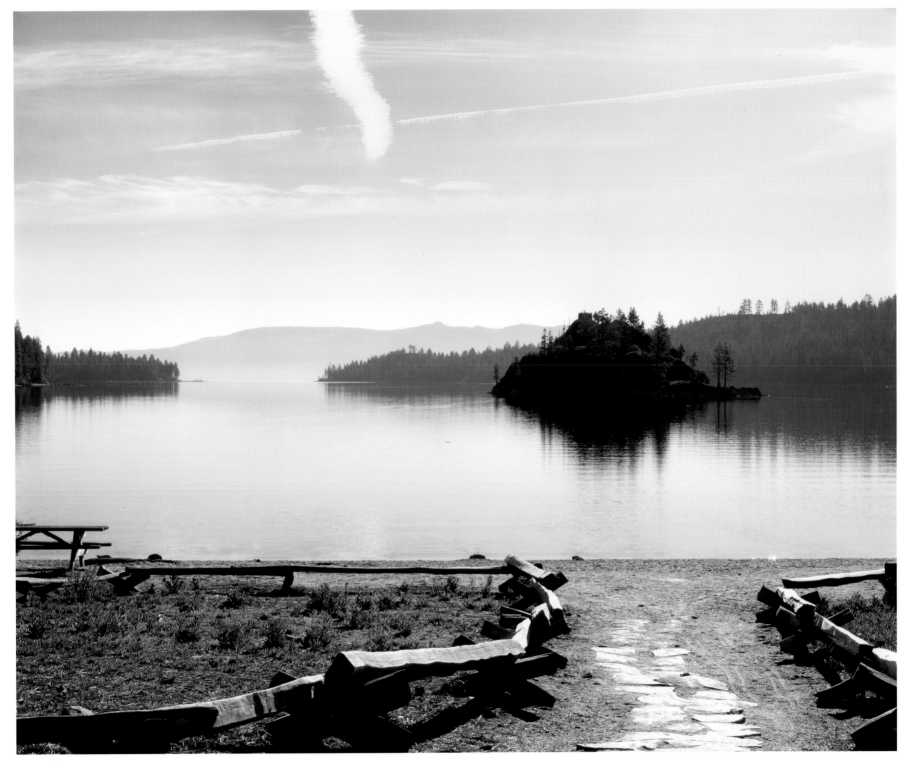

PLATE 40 View from Vikingsholm Emerald Bay State Park

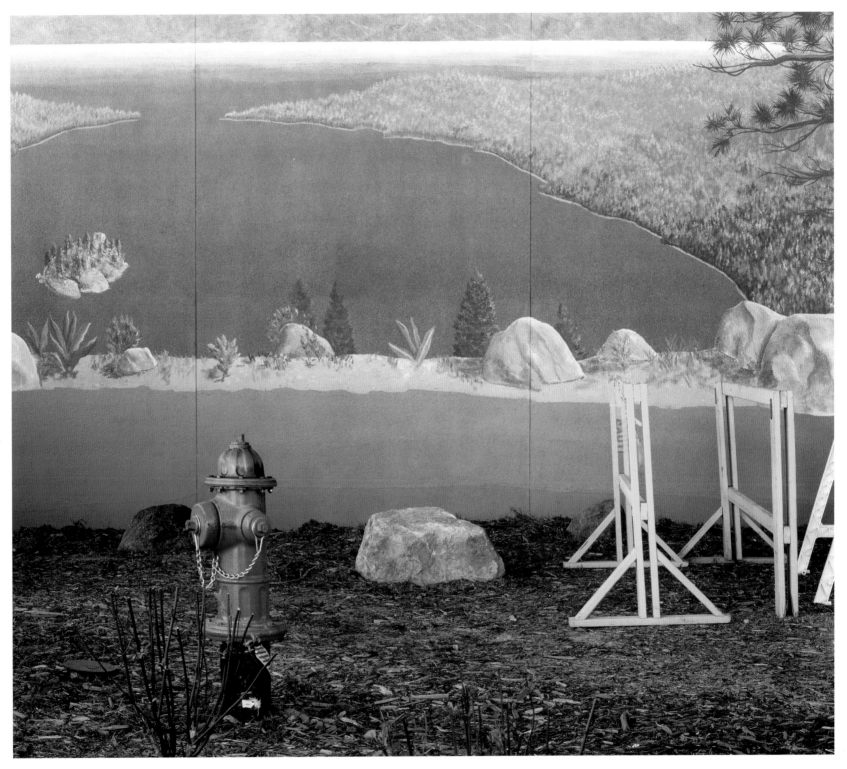

PLATE 41

Mural Stateline

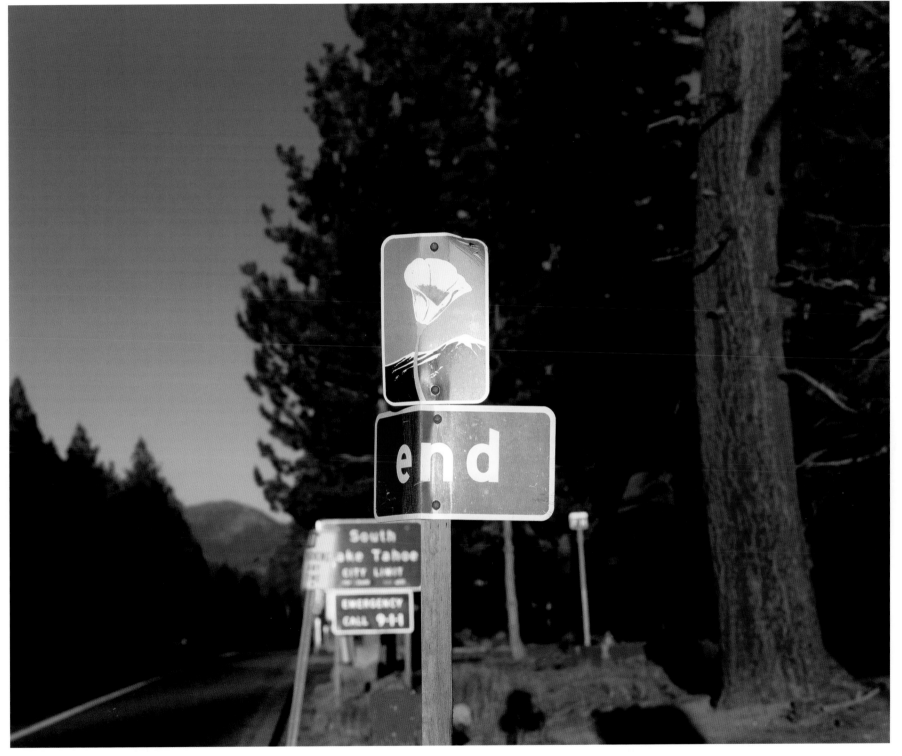

PLATE 42 End South Lake Tahoe

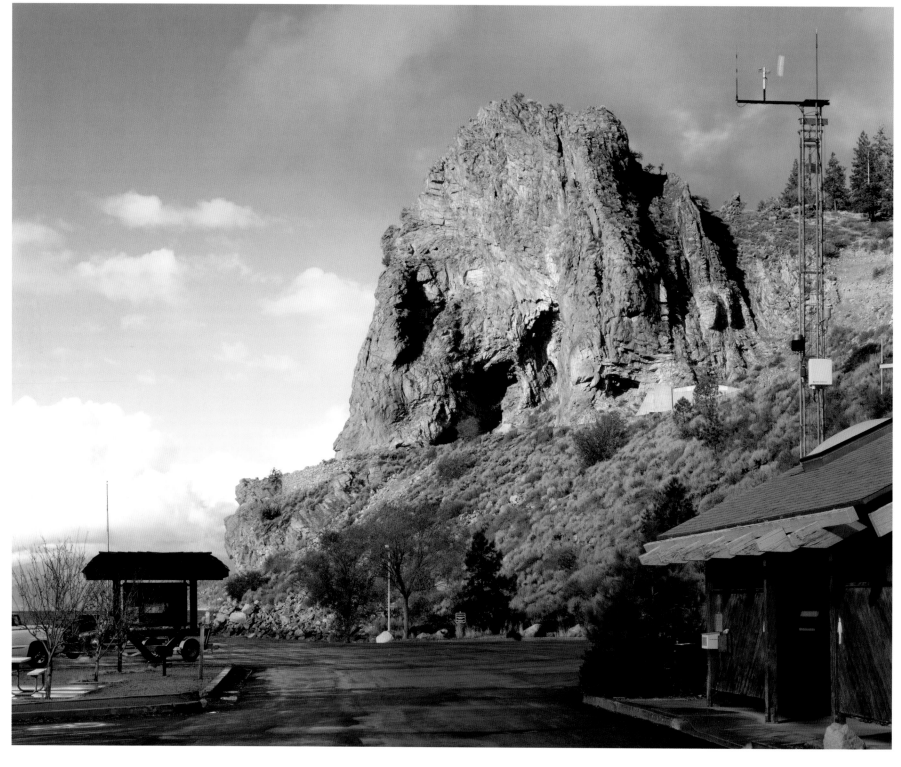

PLATE 43

Cave Rock

Lake Tahoe–Nevada State Park

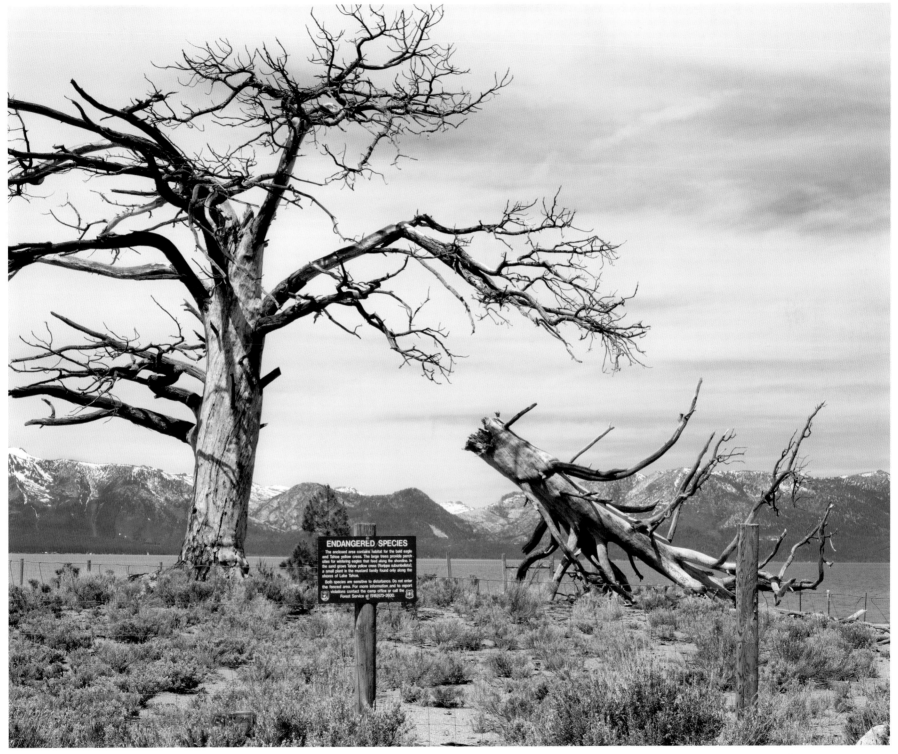

On the sign in the image:

ENDANGERED SPECIES

The enclosed area contains habitat for the bald eagle and Tahoe yellow cress. The large trees provide perch sites for wintering eagles that feed along the shoreline. In the sand grows Tahoe yellow cress (*Rorippa subumbellata*), a small plant in the mustard family found only along the shores of Lake Tahoe.

Both species are sensitive to disturbance. Do not enter the fenced area. For more information and to report violations contact the camp office or call the Forest Service at (916)573-2600.

PLATE 44

Endangered species enclosure Nevada Beach

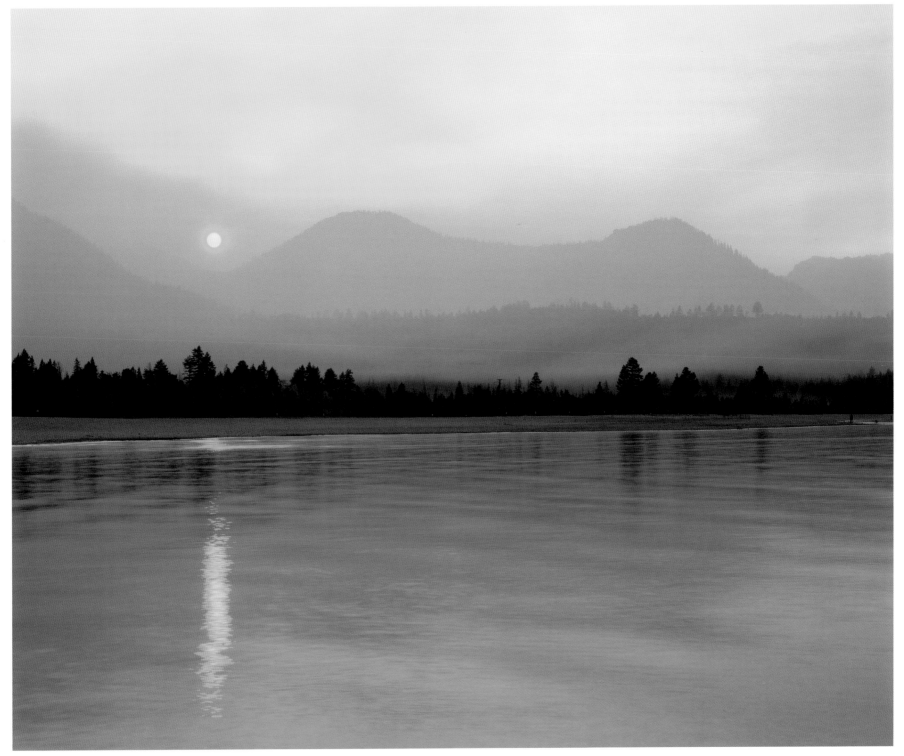

PLATE 45

Forest fire at sunset Baldwin Beach

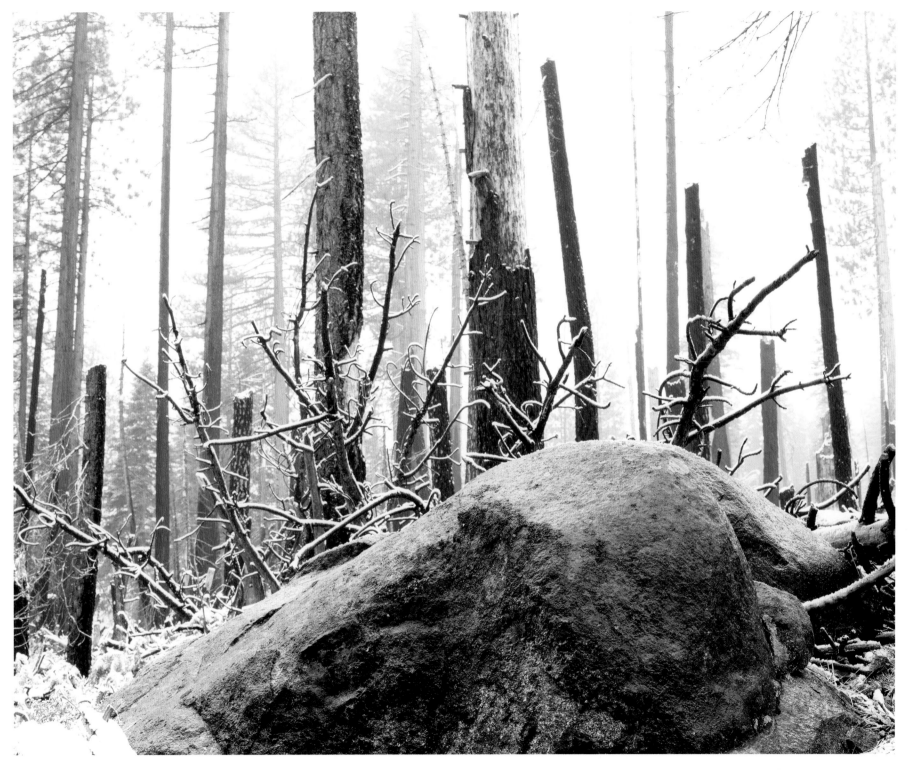

PLATE 46

Controlled burn Sugar Pine Point State Park

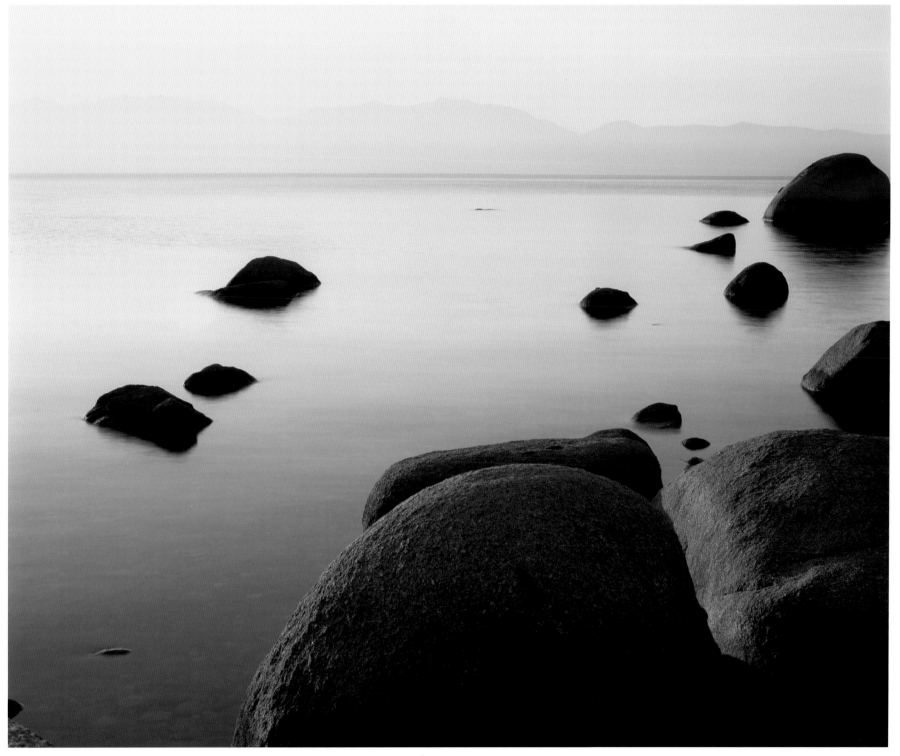

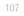

PLATE 47

Shore rocks against smoke Sugar Pine Point State Park

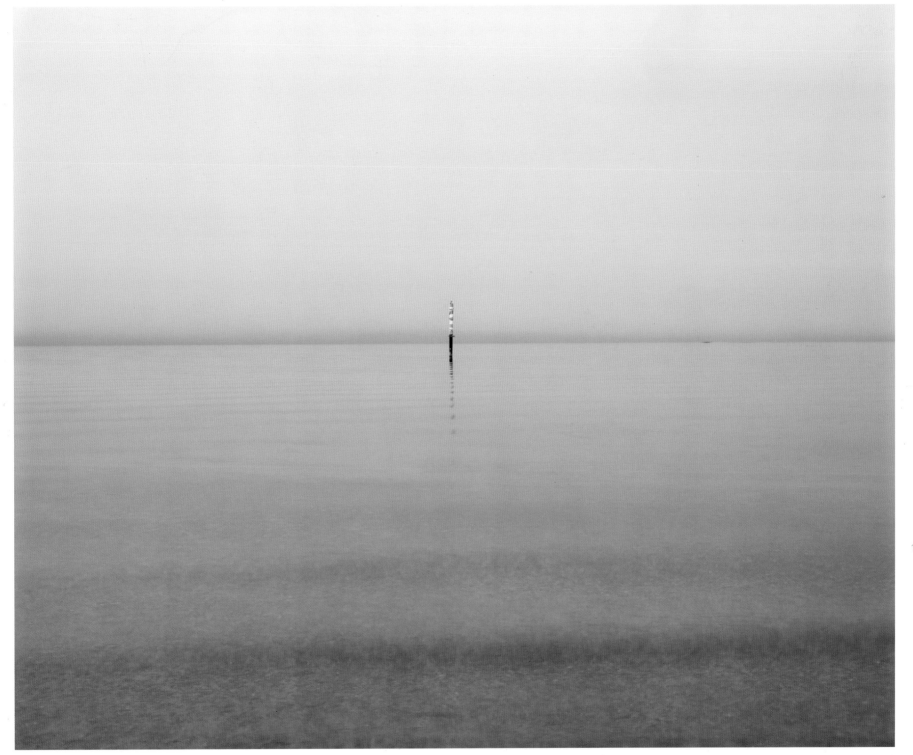

PLATE 48 Swim boundary marker Tallac Point

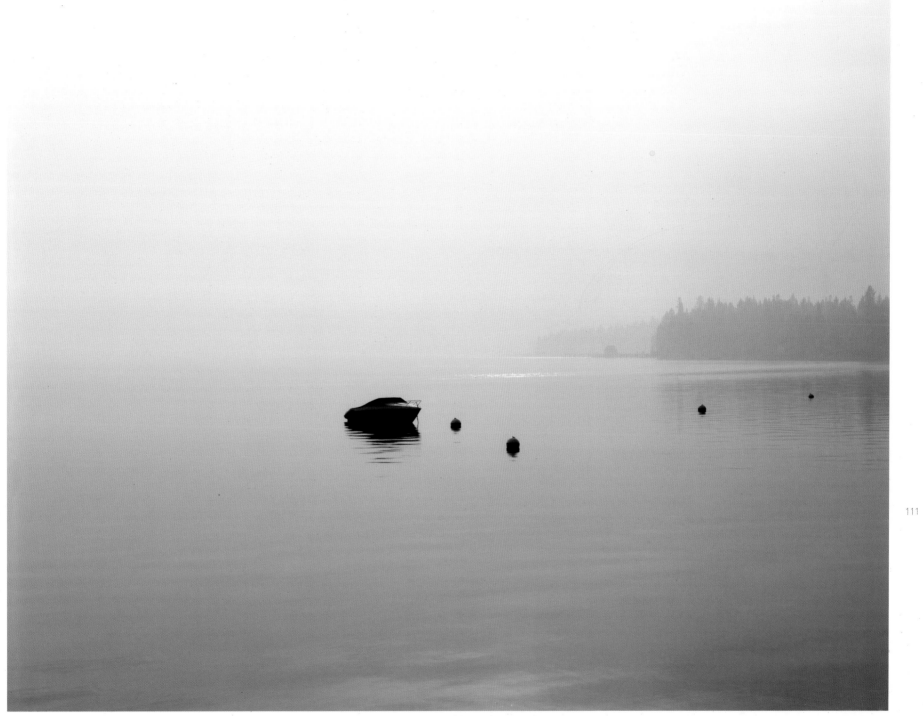

PLATE 49

Moored boat against
forest-fire smoke

Tahoe Pines

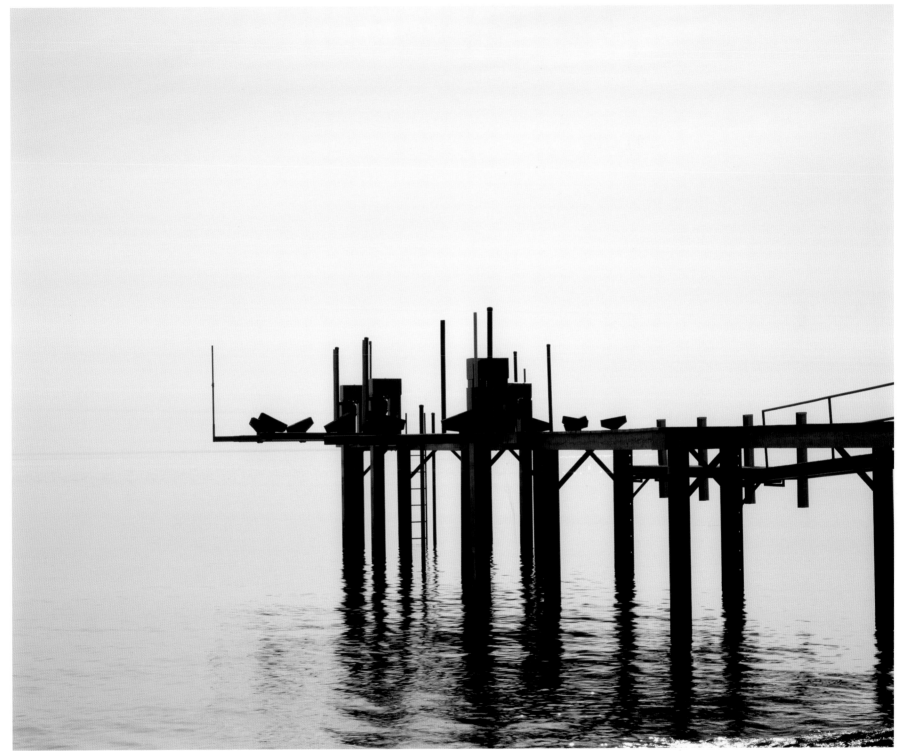

PLATE 50

Steel pier

Tahoe Pines

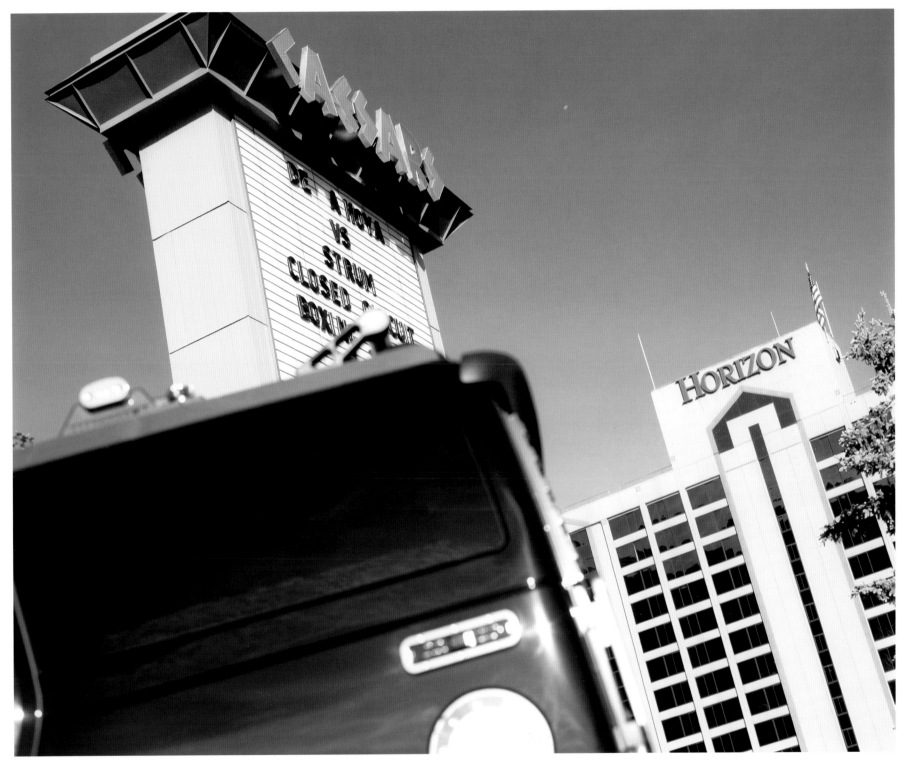

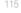

115

PLATE 51

Casinos Stateline

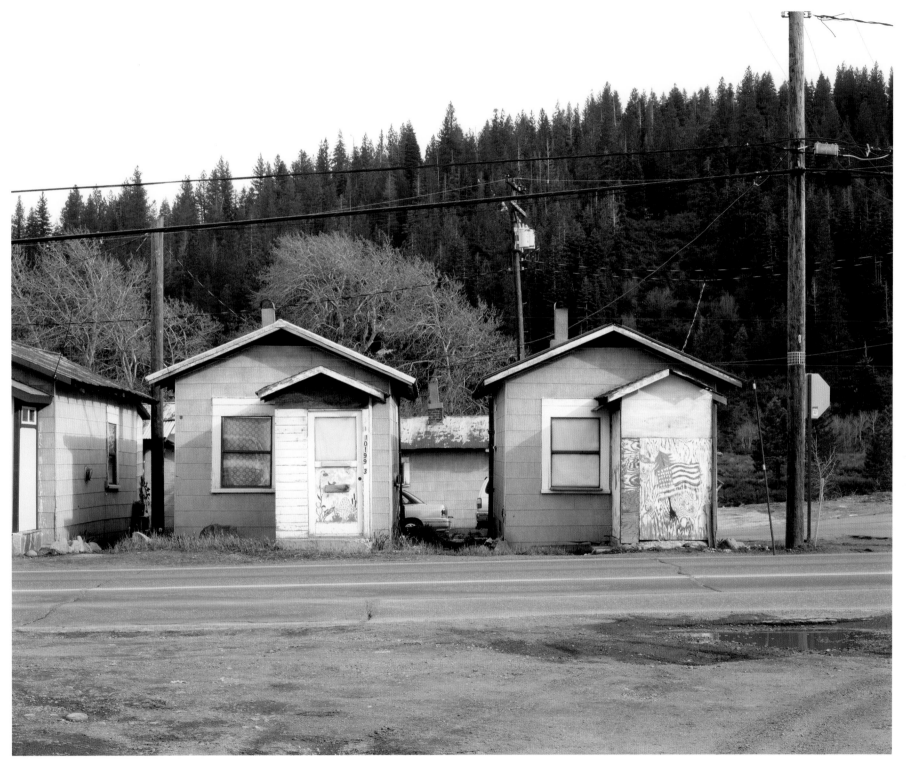

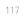

PLATE 52 Cabins Truckee

Roughing It Chapter 23

Mark Twain

Photography by Carleton Watkins

If there is any life that is happier than the life we led on our timber ranch for the next two or three weeks, it must be a sort of life which I have not read of in books or experienced in person. We did not see a human being but ourselves during the time, or hear any sounds but those that were made by the wind and the waves, the sighing of the pines, and now and then the far-off thunder of an avalanche. The forest about us was dense and cool, the sky above us was cloudless and brilliant with sunshine, the broad lake before us was glassy and clear, or rippled and breezy, or black and storm-tossed, according to Nature's mood; and its circling border of mountain domes, clothed with forests, scarred with landslides, cloven by canyons and valleys, and helmeted with glittering snow, fitly framed and finished the noble picture. The view was always fascinating, bewitching, entrancing. The eye was never tired of gazing, night or day, in calm or storm; it suffered but one grief, and that was that it could not look always, but must close sometimes in sleep.

We slept in the sand close to the water's edge, between two protecting boulders, which took care of the stormy night-winds for us. We never took any paregoric to make us sleep. At the first break of dawn we were always

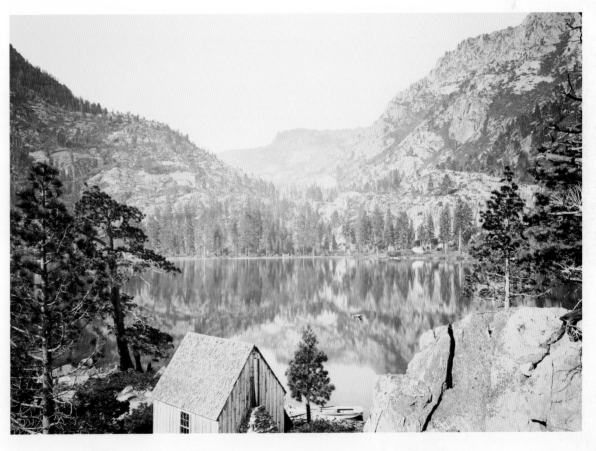

119

Emerald Bay from the Island,
Lake Tahoe

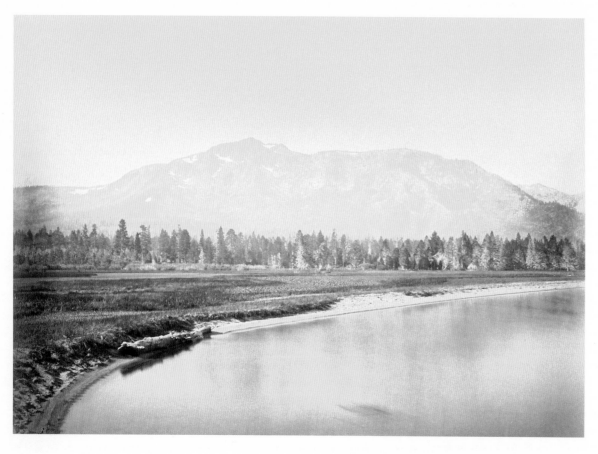

Mt. Tallac, Lake Tahoe

120

up and running footraces to tone down excess of physical vigor and exuberance of spirits. That is, Johnny was—but I held his hat. While smoking the pipe of peace after breakfast we watched the sentinel peaks put on the glory of the sun, and followed the conquering light as it swept down among the shadows, and set the captive crags and forests free. We watched the tinted pictures grow and brighten upon the water till every little detail of forest, precipice, and pinnacle was wrought in and finished, and the miracle of the enchanter complete. Then to "business."

That is, drifting around in the boat. We were on the north shore. There, the rocks on the bottom are sometimes gray, sometimes white. This gives the marvelous transparency of the water a fuller advantage than it has elsewhere on the lake. We usually pushed out a hundred yards or so from shore, and then lay down on the thwarts, in the sun, and let the boat drift by the hour whither it would. We seldom talked. It interrupted the Sabbath stillness, and marred the dreams the luxurious rest and indolence brought. The shore all along was indented with deep, curved bays and coves, bordered by narrow sand-beaches; and where the sand ended, the steep mountain sides rose right up aloft

into space—rose up like a vast wall a little out of the perpen-
dicular, and thickly wooded with tall pines.

So singularly clear was the water, that where it was
only twenty or thirty feet deep the bottom was so perfectly
distinct that the boat seemed floating in the air! Yes, where
it was even eighty feet deep. Every little pebble was distinct,
every speckled trout, every hand's-breadth of sand. Often,
as we lay on our faces, a granite boulder, as large as a vil-
lage church, would start out of the bottom apparently, and
seem climbing up rapidly to the surface, till presently it
threatened to touch our faces, and we could not resist the
impulse to seize an oar and avert the danger. But the boat
would float on, and the boulder descend again, and then we
could see that when we had been exactly above it, it must
still have been twenty or thirty feet below the surface. Down
through the transparency of these great depths, the water
was not merely transparent, but dazzlingly, brilliantly so.
All objects seen through it had a bright, strong vividness,
not only of outline, but of every minute detail, which they
would not have had when seen simply through the same
depth of atmosphere. So empty and airy did all spaces seem
below us, and so strong was the sense of floating high aloft

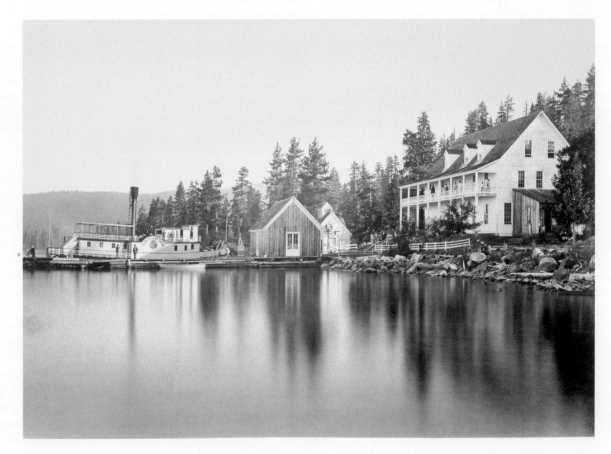

121

WATKINS G

Warm Springs, Lake Tahoe

in mid-nothingness, that we called these boat-excursions "balloon-voyages."

We fished a good deal, but we did not average one fish a week. We could see trout by the thousand winging about in the emptiness under us, or sleeping in shoals on the bottom, but they would not bite—they could see the line too plainly, perhaps. We frequently selected the trout we wanted, and rested the bait patiently and persistently on the end of his nose at a depth of eighty feet, but he would only shake it off with an annoyed manner, and shift his position.

We bathed occasionally, but the water was rather chilly, for all it looked so sunny. Sometimes we rowed out to the "blue water," a mile or two from shore. It was as dead blue as indigo there, because of the immense depth. By official measurement the lake in its centre is one thousand five hundred and twenty-five feet deep!

Sometimes, on lazy afternoons, we lolled on the sand in camp, and smoked pipes and read some old well-worn novels. At night, by the camp-fire, we played euchre and seven-up to strengthen the mind—and played them with cards so greasy and defaced that only a whole summer's

acquaintance with them could enable the student to tell the ace of clubs from the jack of diamonds.

We never slept in our "house." It never occurred to us, for one thing; and besides, it was built to hold the ground, and that was enough. We did not wish to strain it.

By and by our provisions began to run short, and we went back to the old camp and laid in a new supply. We were gone all day, and reached home again about nightfall, pretty tired and hungry. While Johnny was carrying the main bulk of the provisions up to our "house" for future use, I took the loaf of bread, some slices of bacon, and the coffee-pot, ashore, set them down by a tree, lit a fire, and went back to the boat to get the frying-pan. While I was at this, I heard a shout from Johnny, and looking up I saw that my fire was galloping all over the premises!

Johnny was on the other side of it. He had to run through the flames to get to the lake shore, and then we stood helpless and watched the devastation.

The ground was deeply carpeted with dry pine-needles, and the fire touched them off as if they were gunpowder. It was wonderful to see with what fierce speed the tall sheet of flame traveled! My coffee-pot was gone, and

everything with it. In a minute and a half the fire seized upon a dense growth of dry manzanita chaparral six or eight feet high, and then the roaring and popping and crackling was something terrific. We were driven to the boat by the intense heat, and there we remained, spell-bound.

Within half an hour all before us was a tossing, blinding tempest of flame! It went surging up adjacent ridges—surmounted them and disappeared in the canyons beyond—burst into view upon higher and farther ridges, presently—shed a grander illumination abroad, and dove again—flamed out again, directly, higher and still higher up the mountain side—threw out skirmishing parties of fire here and there, and sent them trailing their crimson spirals away among remote ramparts and ribs and gorges, till as far as the eye could reach the lofty mountain-fronts were webbed as it were with a tangled net-work of red lava streams. Away across the water the crags and domes were lit with a ruddy glare, and the firmament above was a reflected hell!

Every feature of the spectacle was repeated in the glowing mirror of the lake! Both pictures were sublime, both were beautiful; but that in the lake had a bewildering

richness about it that enchanted the eye and held it with the stronger fascination.

We sat absorbed and motionless through four long hours. We never thought of supper, and never felt fatigue. But at eleven o'clock the conflagration had traveled beyond our range of vision, and then darkness stole down upon the landscape again.

Hunger asserted itself now, but there was nothing to eat. The provisions were all cooked, no doubt, but we did not go to see. We were homeless wanderers again, without any property. Our fence was gone, our house burned down; no insurance. Our pine forest was well scorched, the dead trees all burned up, and our broad acres of manzanita swept away. Our blankets were on our usual sand-bed, however, and so we lay down and went to sleep. The next morning we started back to the old camp, but while out a long way from shore, so great a storm came up that we dared not try to land. So I baled out the seas we shipped, and Johnny pulled heavily through the billows till we had reached a point three or four miles beyond the camp. The storm was increasing, and it became evident that it was better to take the hazard of beaching the boat than go down in a hundred fathoms of water; so we ran in, with tall white-caps following, and I sat down in the stern-sheets and pointed her head-on to the shore. The instant the bow struck, a wave came over the stern that washed crew and cargo ashore, and saved a deal of trouble. We shivered in the lee of a boulder all the rest of the day, and froze all the night through. In the morning the tempest had gone down, and we paddled down to the camp without any unnecessary delay. We were so starved that we ate up the rest of the Brigade's provisions, and then set out to Carson to tell them about it and ask their forgiveness. It was accorded, upon payment of damages.

We made many trips to the lake after that, and had many a hair-breadth escape and blood-curdling adventure which will never be recorded in any history.

Plates 53–80

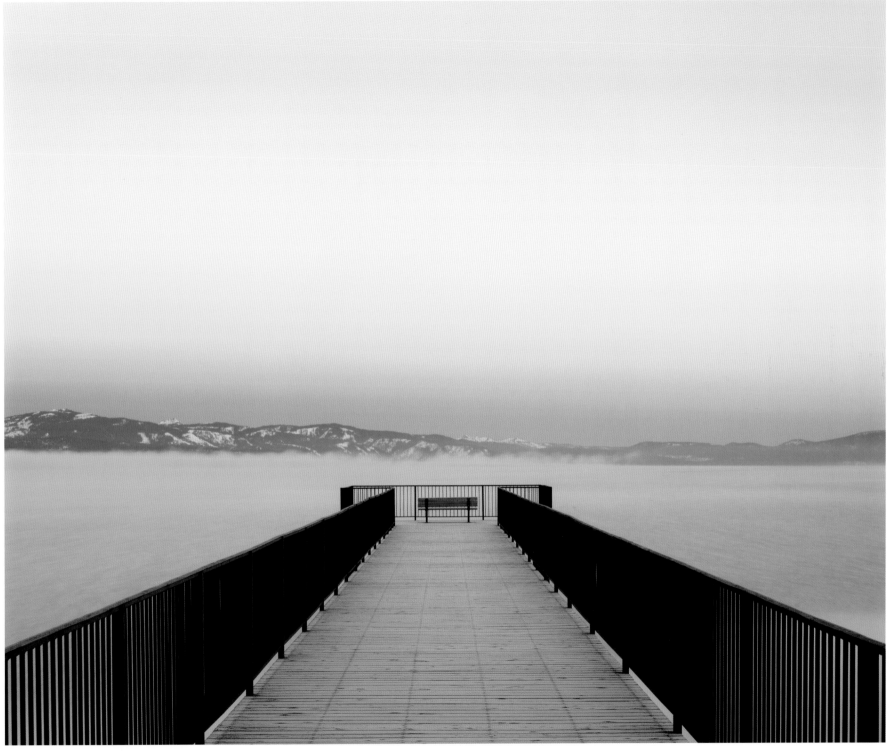

125

PLATE 53

Frozen pier Tahoe Keys

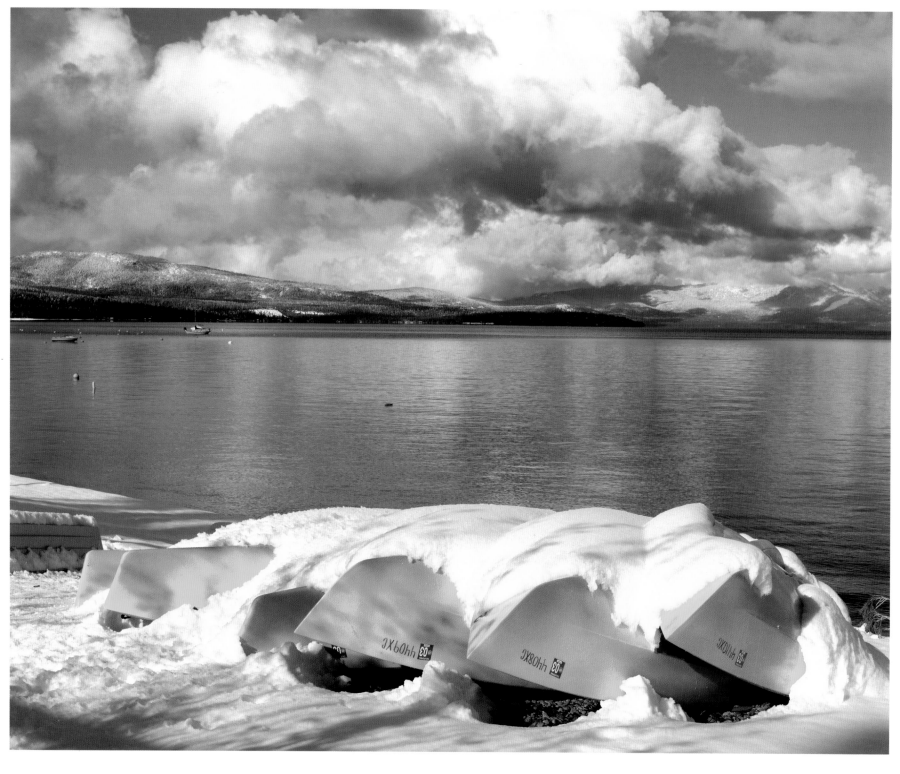

PLATE 54 Kayaks and early snow Homewood

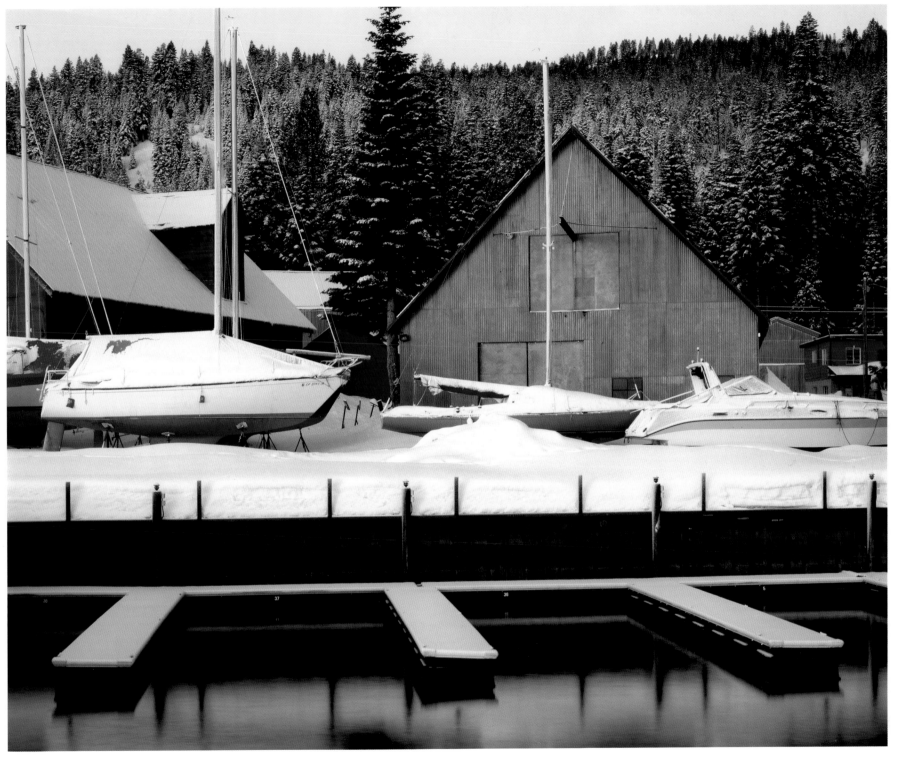

PLATE 55

Obexer's Homewood

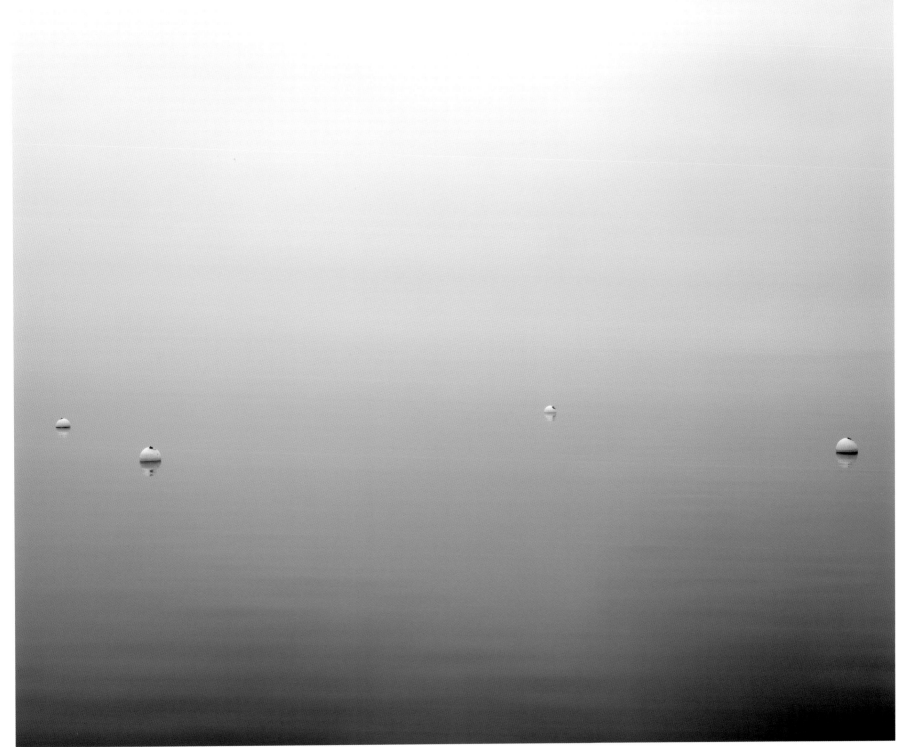

129

PLATE 56

Buoys Homewood

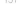

131

PLATE 57 Motorboat in spring Homewood

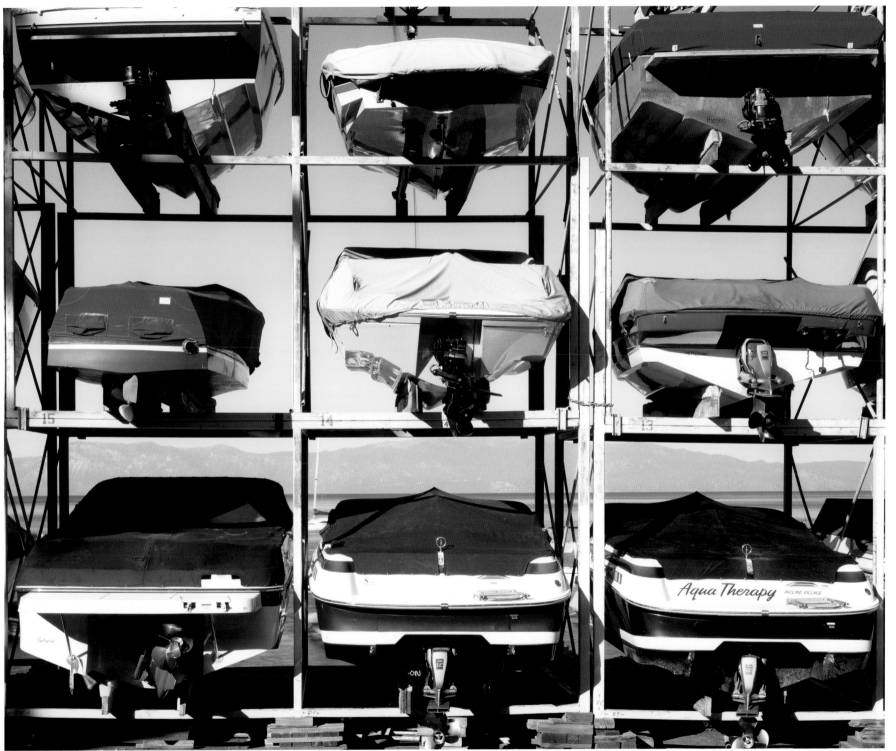

133

PLATE 58

Boat rack Homewood

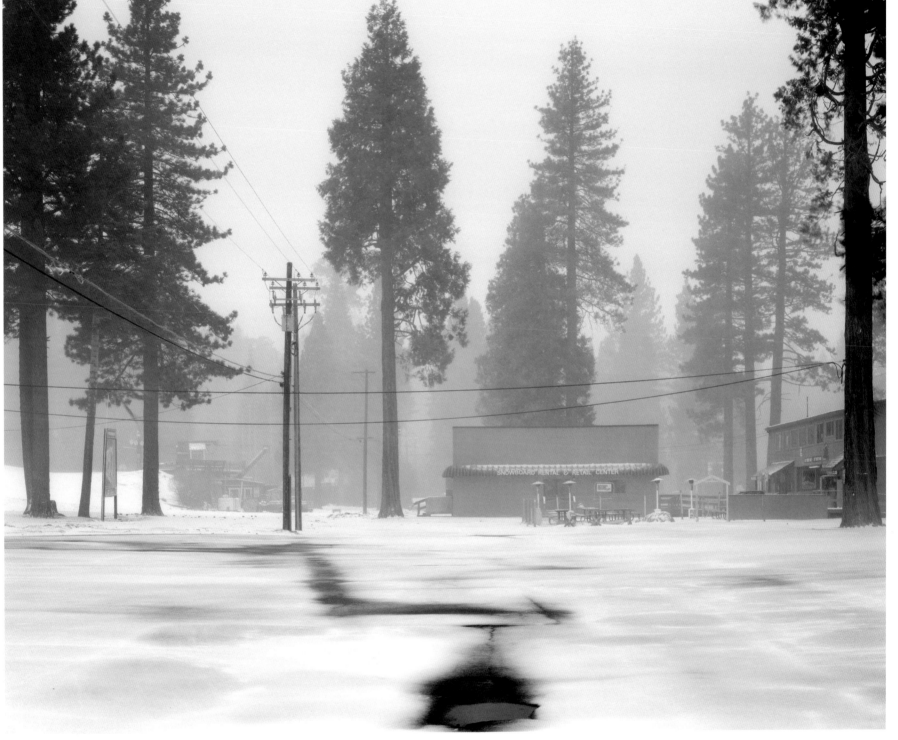

135

PLATE 59

Off-season Homewood

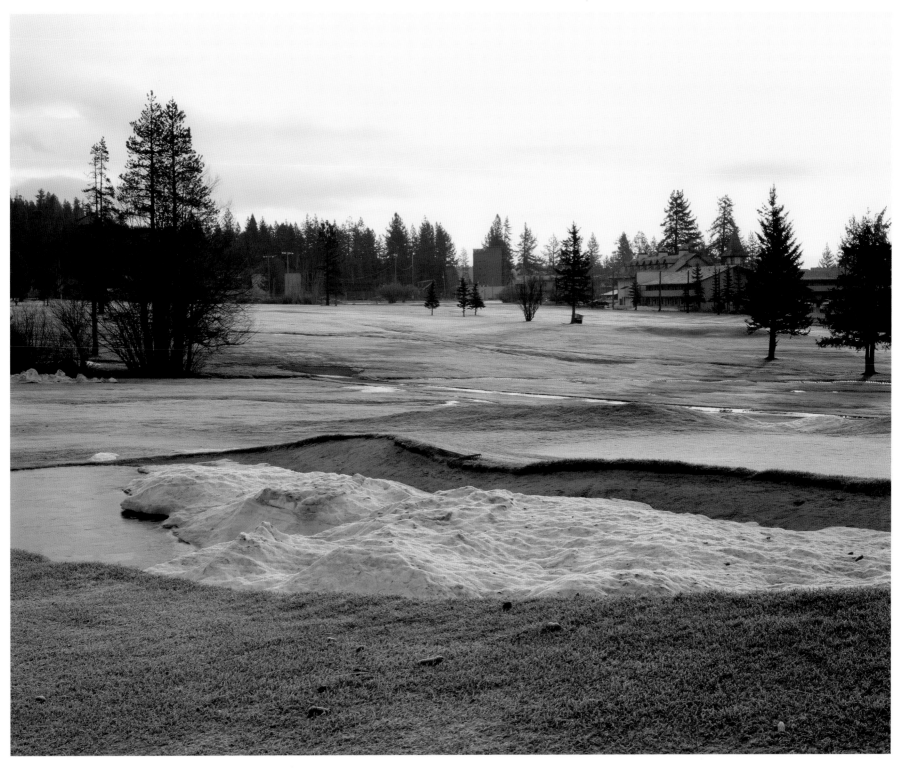

PLATE 60

Golf course Tahoe City

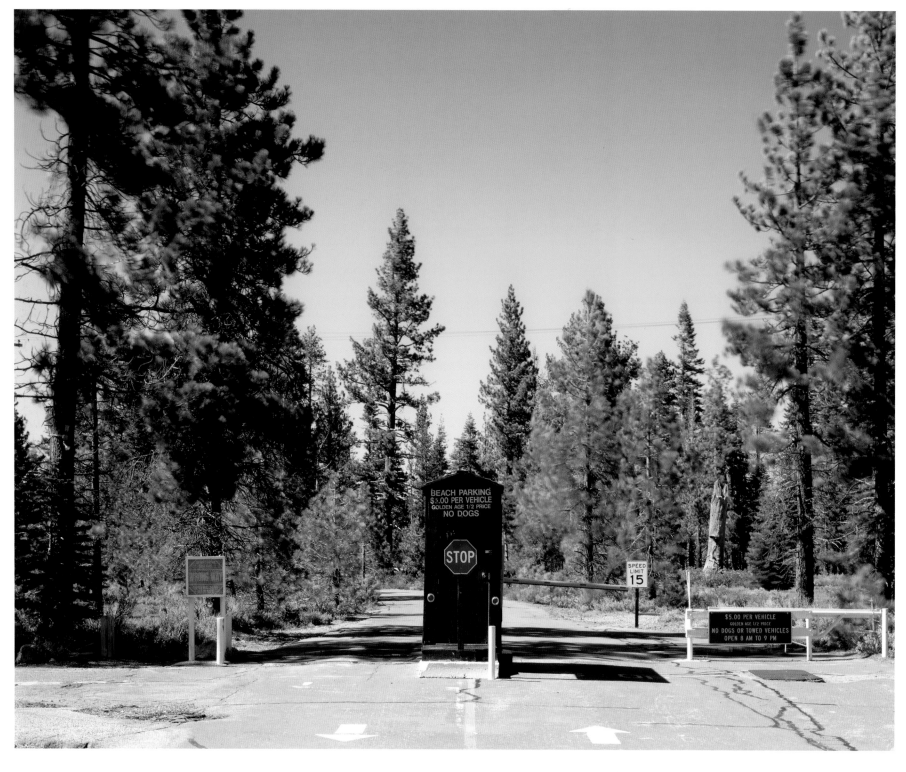

PLATE 61

Kiosk

Baldwin Beach

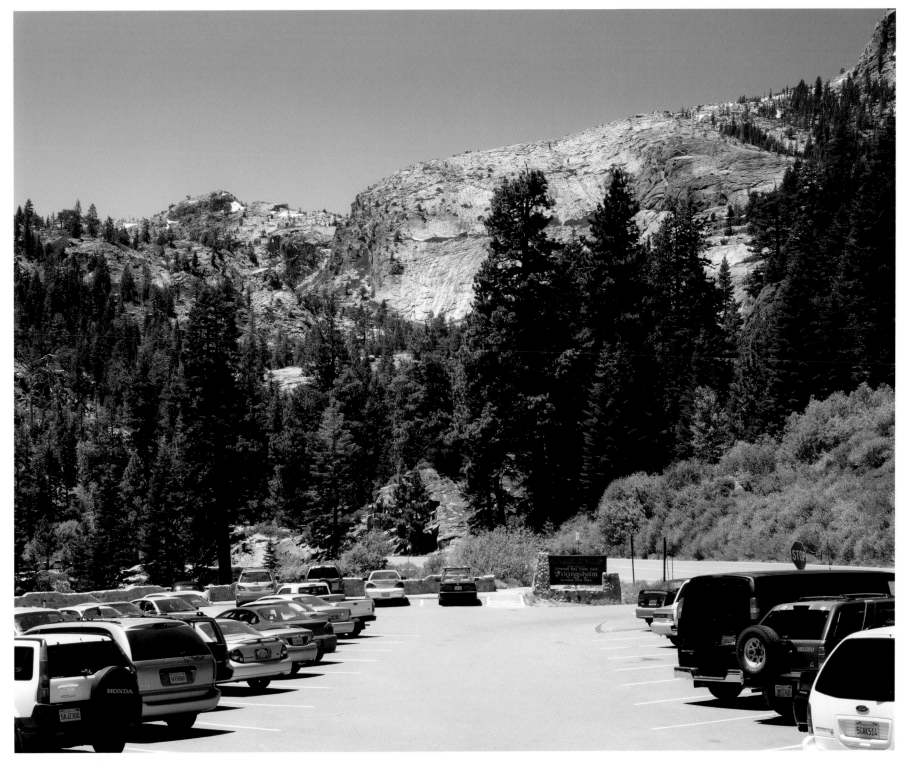

PLATE 62 Parking Emerald Bay State Park

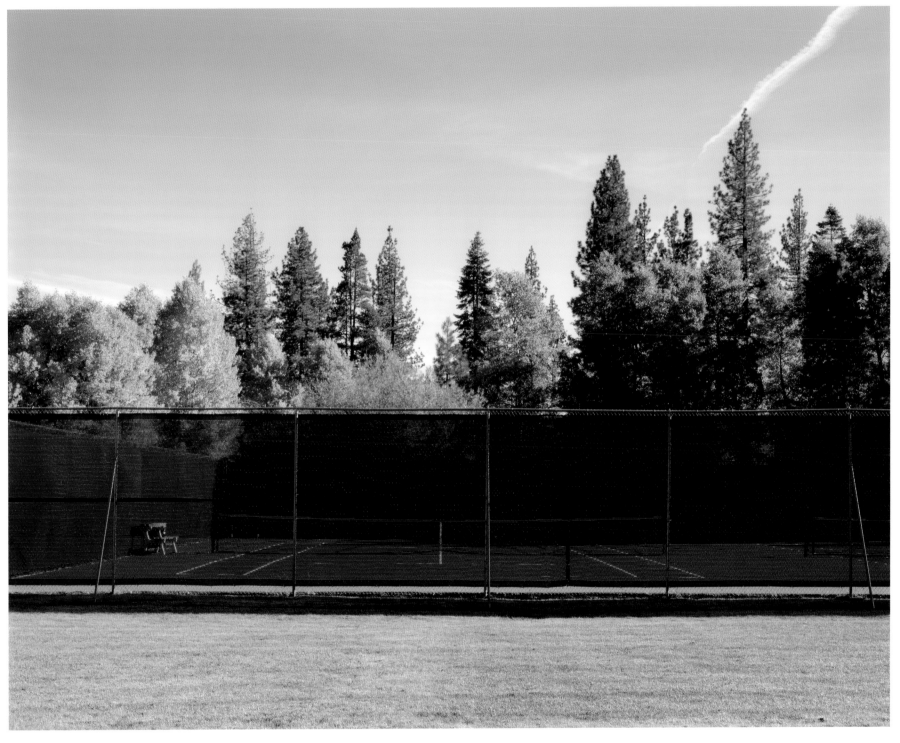

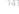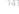141

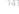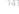

PLATE 63 Tennis court Lake Forest

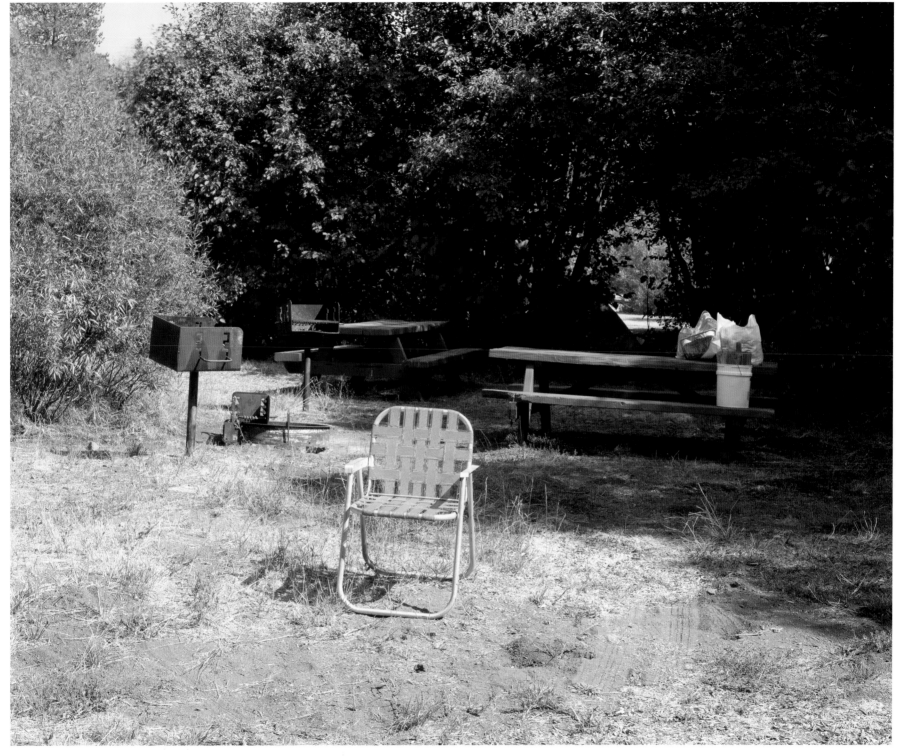

PLATE 64

Campsite

Lake Forest

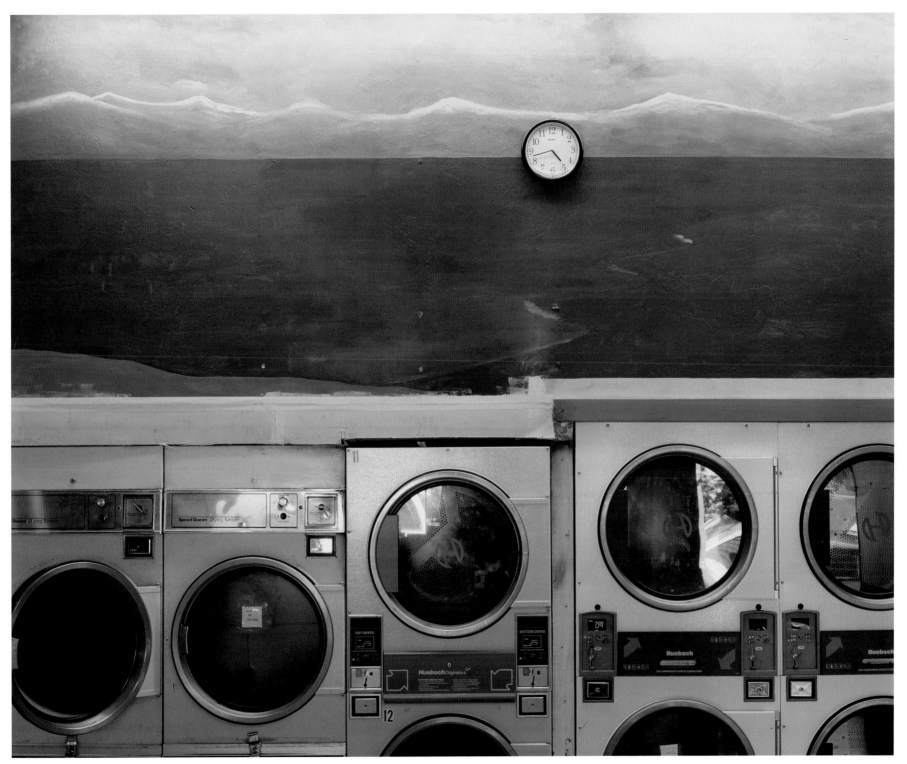

145

PLATE 65

Laundromat Tahoma

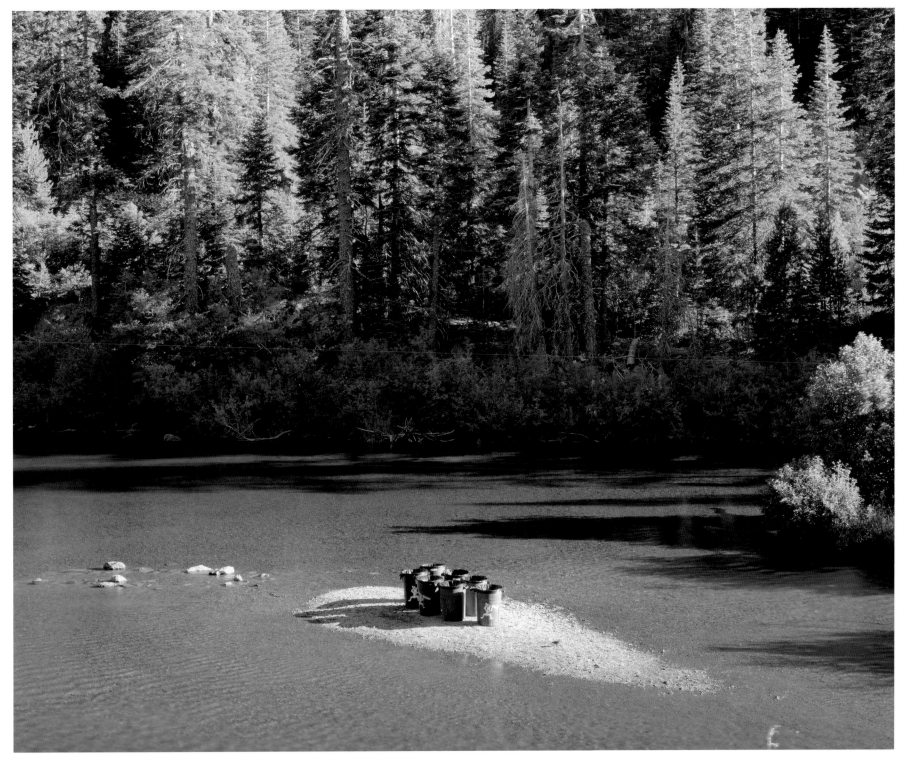

PLATE 66

Trash cans in Truckee River Tahoe City

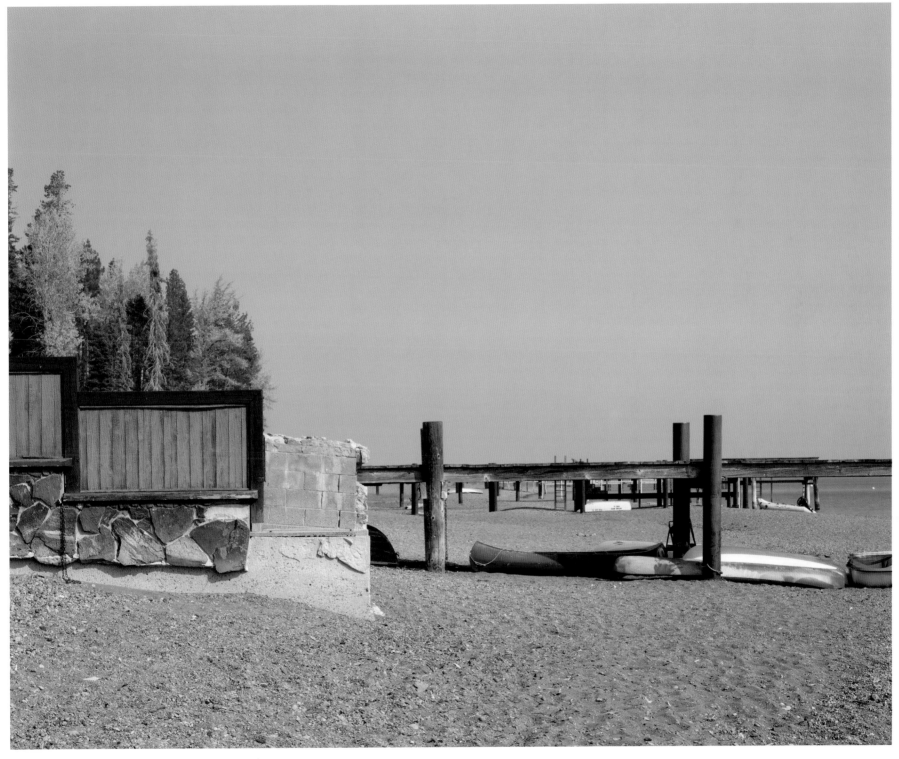

149

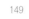

PLATE 67

Property Tahoe Pines

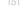

PLATE 68 Lakefront for sale Tahoe Pines

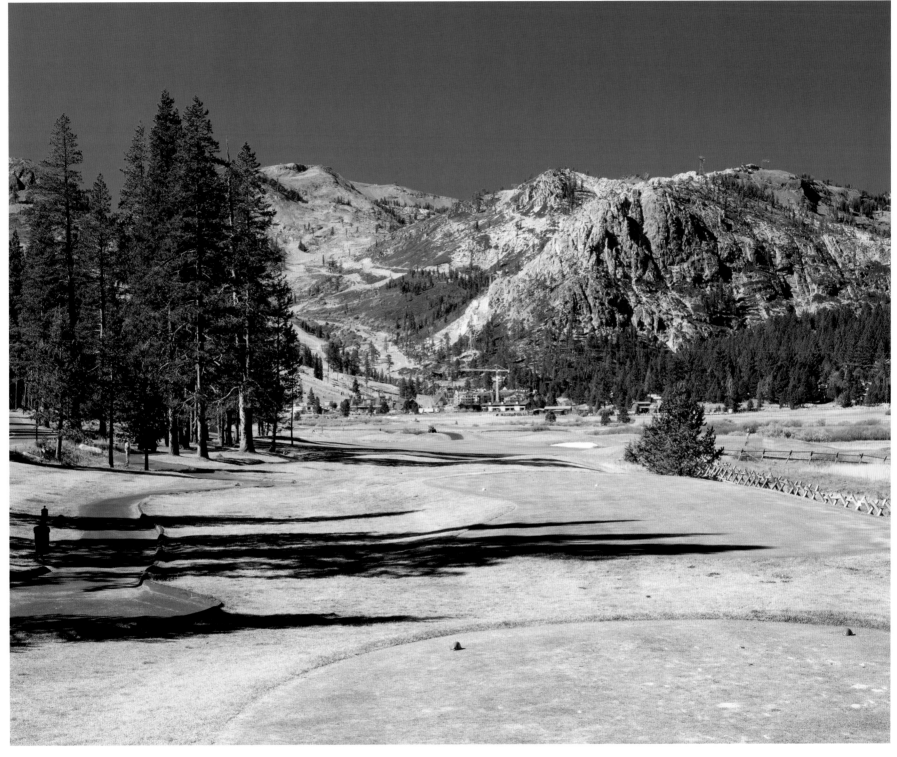

PLATE 69 Golf course Olympic Valley

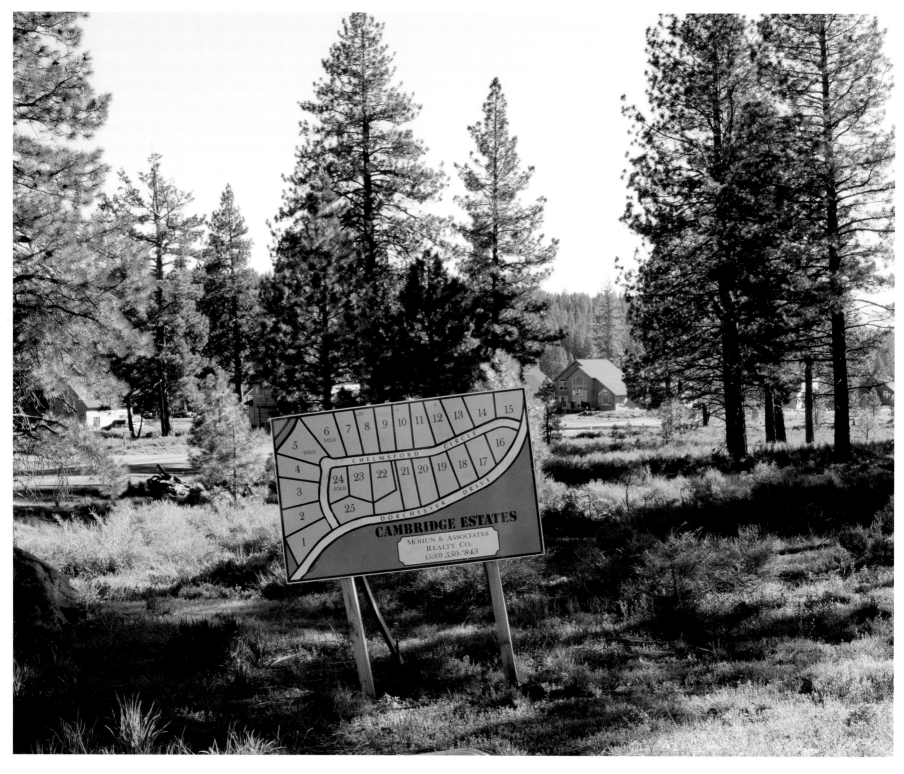

154

The sign in the image reads:

CAMBRIDGE ESTATES

MOHUN & ASSOCIATES
REALTY CO.
(530) 550-'843

(Lot numbers visible on the map: 1–25, with CHELMSFORD CIRCLE, DORCHESTER DRIVE; lots 5, 6, and 24 marked SOLD)

PLATE 70 Development Truckee

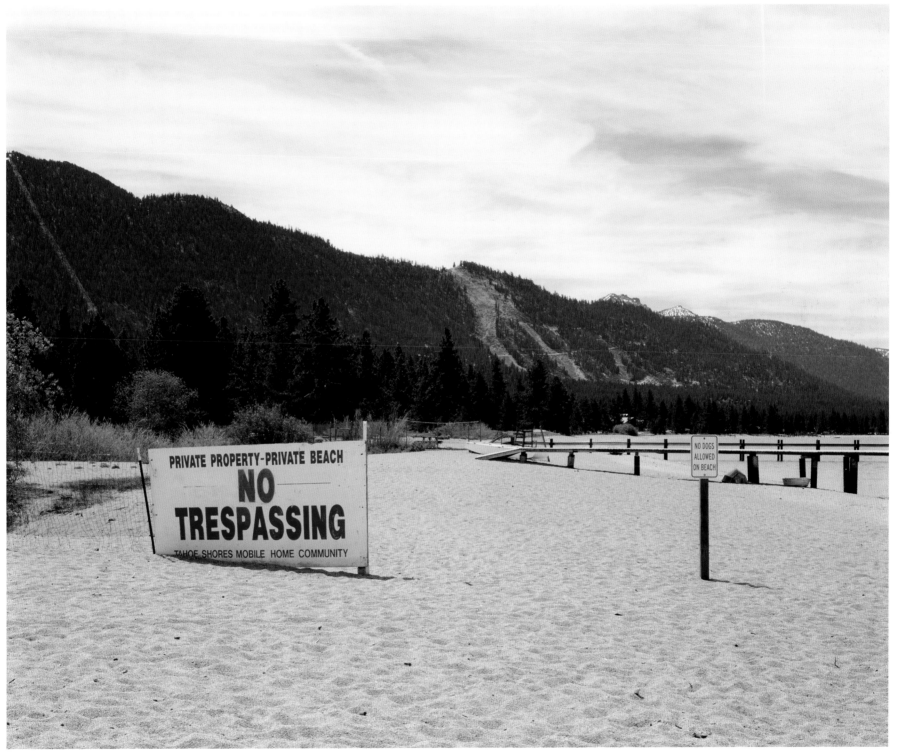

155

PLATE 71

No Trespassing Nevada Beach

PLATE 72 Impromptu boundary Camp Richardson

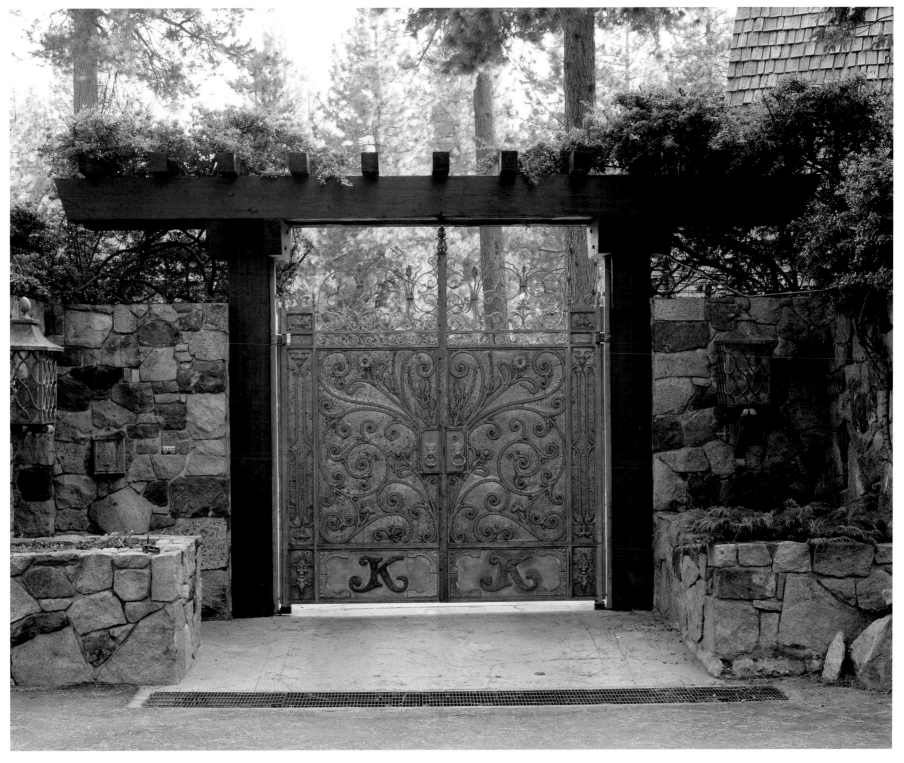

159

PLATE 73

K.K.

Crystal Bay

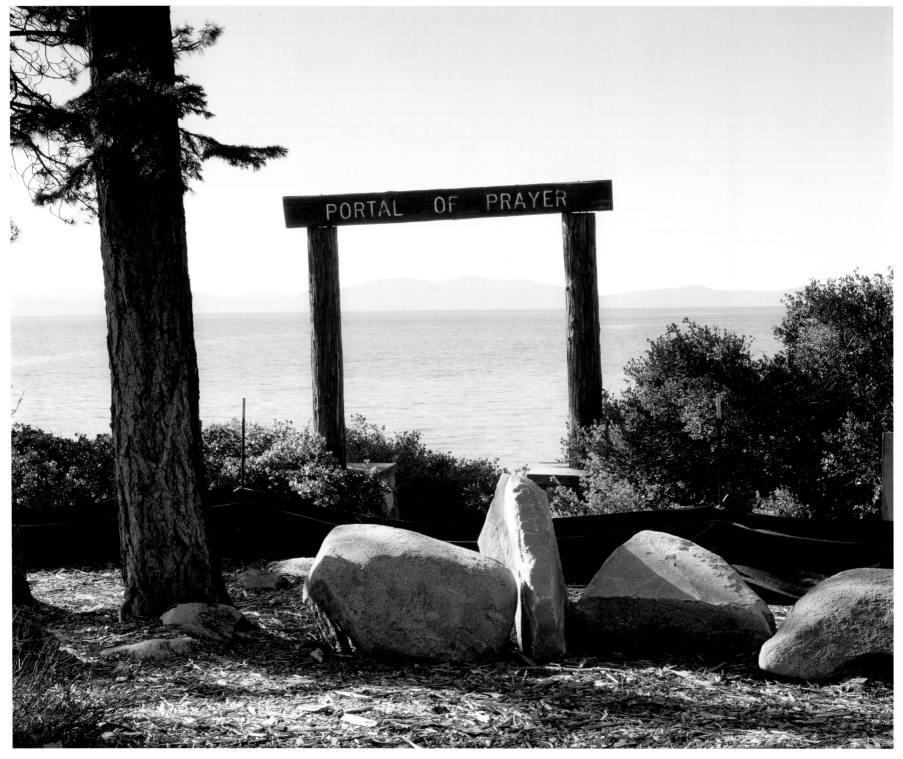

PLATE 74

Portal of Prayer Zephyr Cove

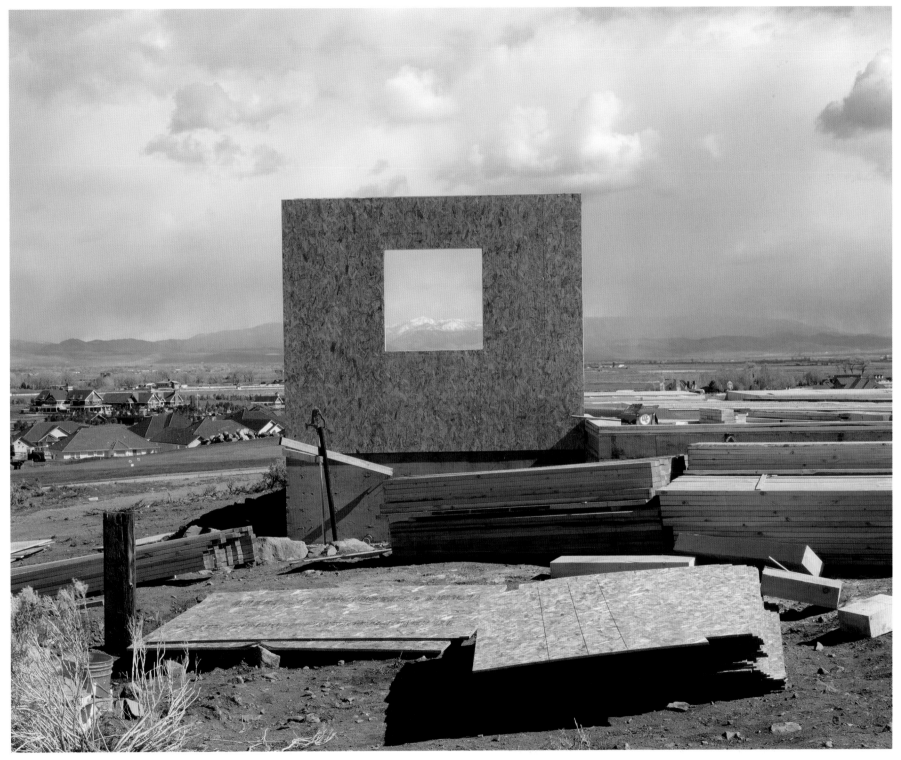

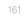

PLATE 75 New construction Carson City

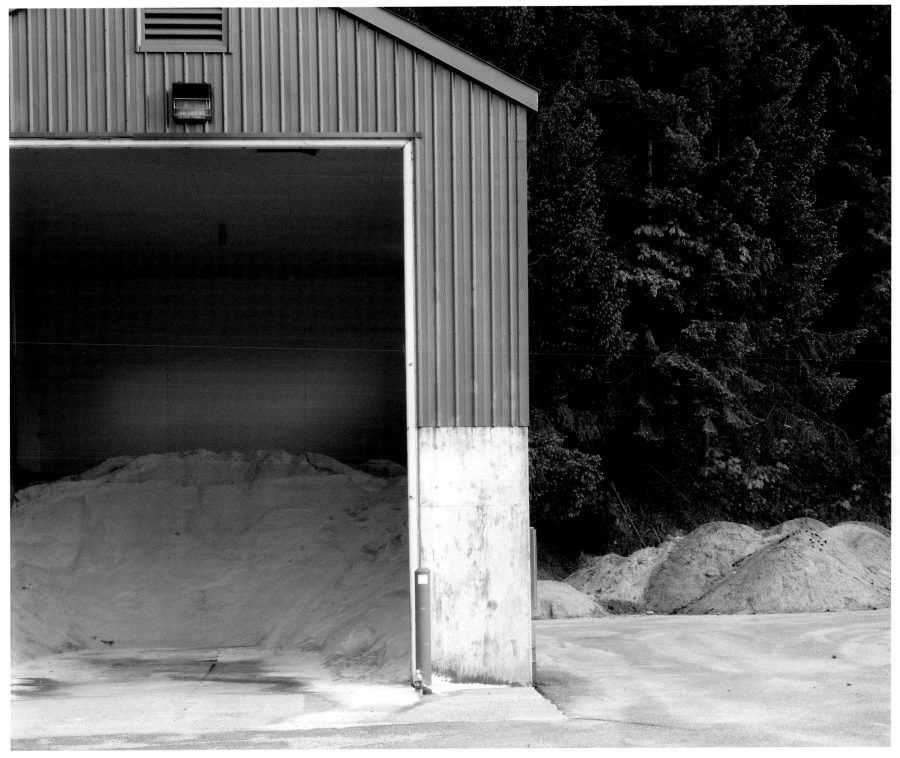

PLATE 76 Caltrans shed Pollock Pines

PLATE 77

Erosion control

Rubicon Bay

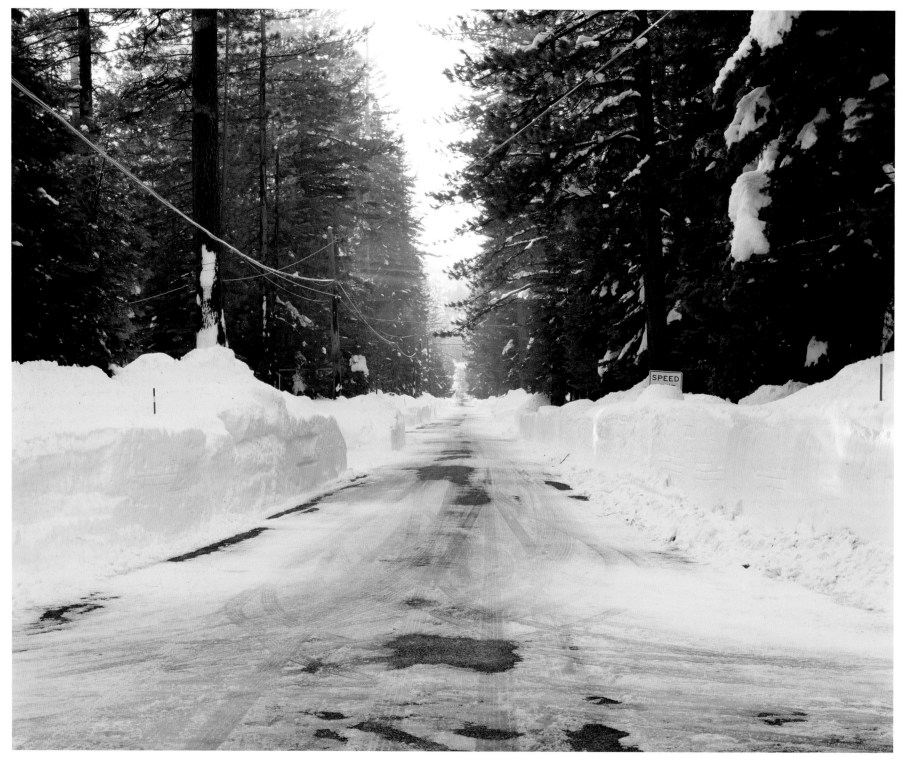

PLATE 78

Plowed Tahoma

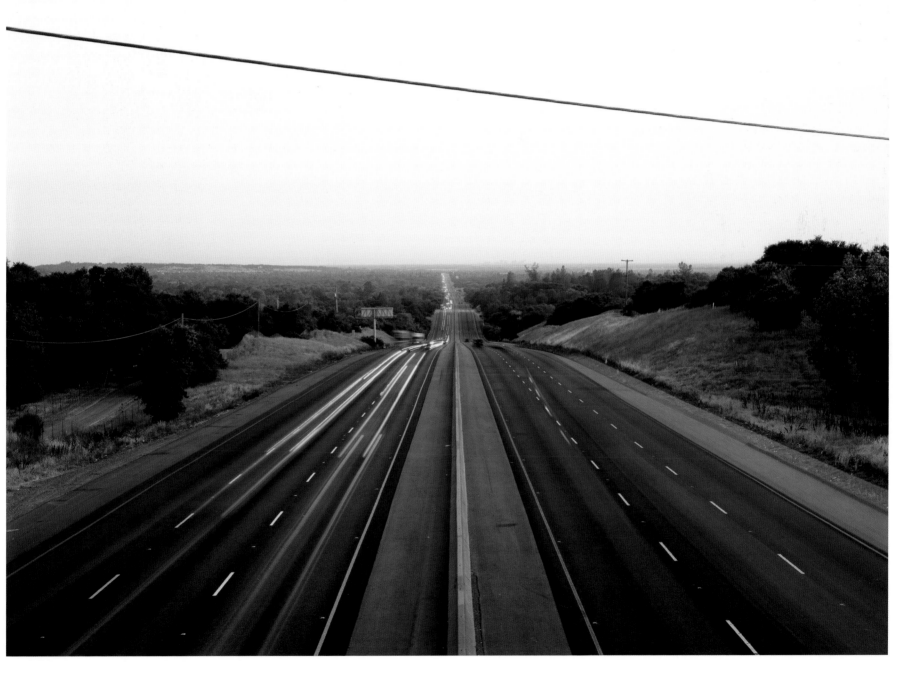

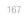

167

PLATE 79

Highway 80 Newcastle

168

The sign in the image reads:

Together we can Save the

Save the plants EARTH Salven las Plantas

The catchment basins clean the water LOS ESTANQUES LIMPIAN EL AGUA

Juntos podemos Salvar el mundo

PLATE 80

Catchment basin Kings Beach

Tahoe in August

Robert Hass

What summer proposes is simply happiness:
heat early in the morning, jays
raucous in the pines. Frank and Ellen have a tennis game
at nine, Bill and Cheryl sleep on the deck
to watch a shower of summer stars. Nick and Sharon
stayed in, sat and talked the dark on,
drinking tea, and Jeanne walked into the meadow
in a white smock to write in her journal
by a grazing horse who seemed to want the company.
Some of them will swim in the afternoon.
Someone will drive to the hardware store to fetch
new latches for the kitchen door. Four o'clock;
the joggers jogging — it is one of them who sees
down the flowering slope the woman with her notebook
in her hand beside the white horse, gesturing, her hair
from a distance the copper color of the hummingbirds
the slant light catches on the slope; the hikers
switchback down the canyon from the waterfall;
the readers are reading, Anna is about to meet Vronsky,
that nice M. Swann is dining in Combray
with the aunts, and Carrie has come to Chicago.
What they want is happiness: someone to love them,
children, a summer by the lake. The woman who sets aside

her book blinks against the fuzzy dark,
re-entering the house. Her daughter drifts downstairs;
out late the night before, she has been napping,
and she's cross. Her mother tells her David telephoned.
"He's such a dear," the mother says, "I think
I make him nervous." The girl tosses her head as the horse
had done in the meadow while Jeanne read it her dream.
"You can call him now, if you want," the mother says,
"I've got to get the chicken started,
I won't listen." "Did I say you would?"
the girl says quickly. The mother who has been slapped
this way before and done the same herself another summer
on a different lake says, "Ouch." The girl shrugs
sulkily. "I'm sorry." Looking down: "Something
about the way you said that pissed me off."
"Hannibal has wandered off," the mother says,
wryness in her voice, she is thinking it is August,
"why don't you see if he's at the Finleys' house
again." The girl says, "God." The mother: "He loves
small children. It's livelier for him there."
The daughter, awake now, flounces out the door,
which slams. It is for all of them the sound of summer.
The mother she looks like stands at the counter snapping beans.

Charts

Historical Water Clarity Of Lake Tahoe
As Measured By Secchi Depth

Feet

0										
25										
50										
75										
100										
125										
150										

1965 1970 1975 1980 1985 1990 1995 2000 2005 2010

Year

From Mark Twain's era until today, if there is one characteristic for which Tahoe is renowned, it is its remarkable clarity. In 1873, Professor John LeConte measured the depth at which he could still view a submerged white dinner plate as it dropped below the surface — his measurement was 108 feet. In 1968, Professor Goldman was able to see a Secchi Disk (the scientific version of a white dinner plate) to a depth of 102 feet. By 2006, Tahoe's famed transparency had fallen to 68 feet. Clouding the lake are ultrafine particles of soil and algae, which are very slow in sinking to Tahoe's great depths. Many of these microscopic particles originate in the sixty-three watersheds that drain into Lake Tahoe. Disturbances to the soil from myriad human activities have increased the rate of erosion especially in the urbanized areas. A reduction in basin wetland area and an increase in the amount of hard surfaces (roads, buildings, etc.) interferes with Tahoe's natural filtration system for cleaning the water before it reaches the lake.

173

Reconstruction Of Environmental History Of Lake Tahoe And Tahoe Basin From Examination Of Sediment Cores

By examining sediment cores taken from the bottom of Lake Tahoe and the deposition of phytoplankton (as biogenic silica from diatoms) into the sediment, we find evidence of algae's historic rate of growth, also known as algal primary production or PPr. Algal growth contributes to the observed reduction in lake clarity. Prior to the Comstock era (1860–1900), it appears that both erosion and algal growth were very low. However, the watershed disturbance resulting from the clear-cut logging of the Comstock era produced very high levels of erosion and, presumably, loss of water clarity — seven times their prehistoric levels. As second-growth forests became established during the twentieth century, the watershed stabilized and returned water quality to near prehistoric levels. The advent of the Urbanization Era has resulted in yet another significant decline in water quality.

174

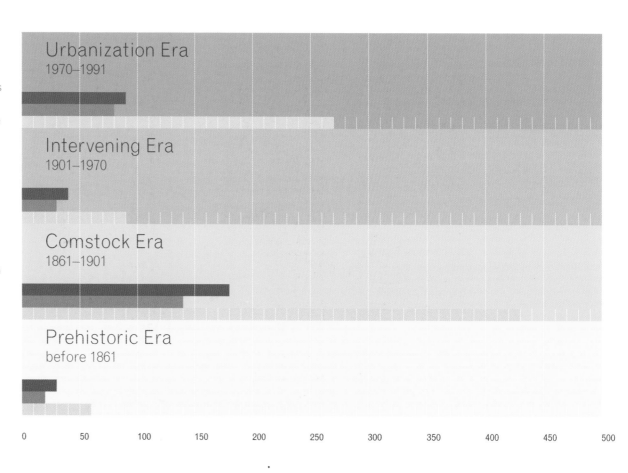

Urbanization Era
1970–1991

Intervening Era
1901–1970

Comstock Era
1861–1901

Prehistoric Era
before 1861

0 50 100 150 200 250 300 350 400 450 500

■ Mass Sedimentation Rate in g / m² / y [grams per square meter per year]
■ Biogenic Silica Flux in g / m² / y [grams per square meter per year]
■ Average PPr [algal primary production] in g C / m² / y [grams of carbon per square meter per year]

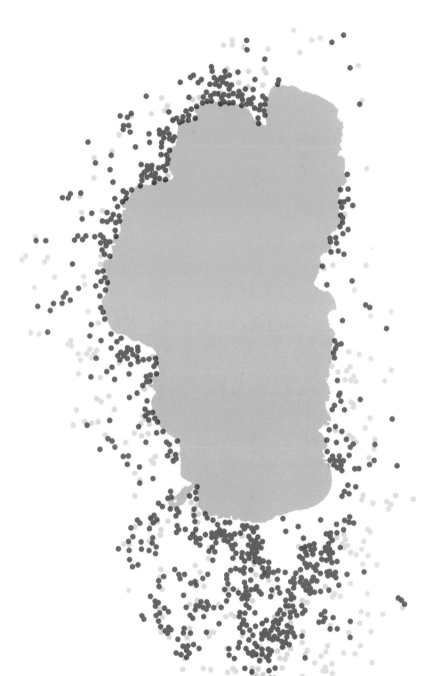

In the Lake Tahoe Basin, humans have replaced nature as the chief cause of wildfire. These fires tend to be larger, more frequent, and more destructive than natural fires. Much of California's environment has become well adapted to fire over millions of years. Many plants in the Sierra Nevada thrive as a result of low to moderate intensity fire. Timber harvesting of old-growth forests and seventy-five years of excellent fire suppression in the Tahoe Basin has shifted the forest composition away from Jeffrey and lodgepole pine toward white fir. This imbalance has created denser, younger, unhealthy forests with heavier fuel loads on the ground, which are increasingly prone to high-intensity fire. These devastating fires can destroy a forest. Baked soils hinder regrowth and, in the Tahoe Basin, erosion can severely degrade lake clarity.

Ignition Causes

- Human
- Natural

175

WATKINS A
Page 71. Carleton E. Watkins, *View from Round Top. Looking westward. Pyramid, Round Top Proper, Azimuth Mark in left background. Mt. Tallac in middle background. Woods Lake in foreground under it. Lake Tahoe to right of Mt. Tallac. Red Mountain and Carson Pass on extreme right.* Collection of Photographs by Carleton E. Watkins, ca. 1874-1890. No. 1281. Photographic albumen print on 22 x 28 inch mount. Courtesy of the Phoebe Hearst Museum of Anthropology. University of California, Berkeley.

WATKINS B
Page 72. Carleton E. Watkins, *A Storm on Lake Tahoe.* Collection of Photographs by Carleton E. Watkins, ca. 1874-1890. No. 1016. Photographic albumen print on 22 x 28 inch mount. Courtesy of the Phoebe Hearst Museum of Anthropology. University of California, Berkeley.

WATKINS C
Page 73. Carleton E. Watkins, *Glenbrook, Lake Tahoe.* Collection of Photographs by Carleton E. Watkins, ca. 1874-1890. No. 1017. Photographic albumen print on 22 x 28 inch mount. Courtesy of the Phoebe Hearst Museum of Anthropology. University of California, Berkeley.

WATKINS D
Page 74. Carleton E. Watkins, *Lake Tahoe, View from Tahoe City.* Collection of Photographs by Carleton E. Watkins, ca. 1874-1890. No. 1003. Photographic albumen print on 22 x 28 inch mount. Courtesy of the Phoebe Hearst Museum of Anthropology. University of California, Berkeley.

WATKINS E
Page 119. Carleton E. Watkins, *Emerald Bay from the Island, Lake Tahoe.* Collection of Photographs by Carleton E. Watkins, ca. 1874-1890. No. 1008. Photographic albumen print on 22 x 28 inch mount. Courtesy of the Phoebe Hearst Museum of Anthropology. University of California, Berkeley.

WATKINS F
Page 120. Carleton E. Watkins, *Mt. Tallac, Lake Tahoe.* Collection of Photographs by Carleton E. Watkins, ca. 1874-1890. No. 1011. Photographic albumen print on 22 x 28 inch mount. Courtesy of the Phoebe Hearst Museum of Anthropology. University of California, Berkeley.

WATKINS G
Page 121. Carleton E. Watkins, *Warm Springs, Lake Tahoe.* Collection of Photographs by Carleton E. Watkins, ca. 1874-1890. No. 1005. Photographic albumen print on 22 x 28 inch mount. Courtesy of the Phoebe Hearst Museum of Anthropology. University of California, Berkeley.

Page 171. "Tahoe in August" from *Human Wishes* by Robert Hass. Copyright © 1989 by Robert Hass. Reprinted by permission of HarperCollins Publishers.

Page 173. *Historical Water Clarity Of Lake Tahoe.* University of California, Davis — Tahoe Environmental Research Center.

Page 174. *Reconstruction Of Environmental History Of Lake Tahoe And Tahoe Basin.* Heyvaert, A.C. 1998. The Biogeochemistry and Paleolimnology of Sediments from Lake Tahoe, California–Nevada. Ph.D. dissertation. University of California, Davis.

Page 175. *Lake Tahoe Basin Fire Ignitions.* 2000. Lake Tahoe Watershed Assessment: Volume II. USDA Forest Service.